IMAGES

of Ameri

THE SAN
LORENZO VALLEY

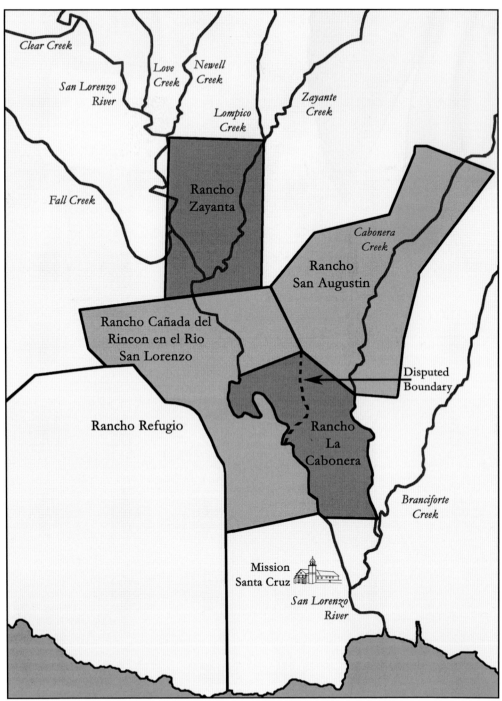

This is a map of the original Mexican land grants, prior to California becoming a state in 1848, as described in the introduction. (Author's collection.)

ON THE COVER: William B. Peery, son of Boulder Creek pioneer Joseph W. Peery, stands with his hands on his hips on top of a giant redwood. This tree was the first to be felled in the forests above Big Basin by the Hartman and Peery Lumber Company. (Courtesy of the San Lorenzo Valley Museum.)

IMAGES
of America

THE SAN
LORENZO VALLEY

Lisa Robinson

ARCADIA
PUBLISHING

Copyright © 2012 by Lisa Robinson
ISBN 978-0-7385-9229-9

Published by Arcadia Publishing
Charleston, South Carolina

Printed in the United States of America

Library of Congress Control Number: 2011939991

For all general information, please contact Arcadia Publishing:
Telephone 843-853-2070
Fax 843-853-0044
E-mail sales@arcadiapublishing.com
For customer service and orders:
Toll-Free 1-888-313-2665

Visit us on the Internet at www.arcadiapublishing.com

This book is dedicated to Nancy McCarthy, whose beautifully researched book, Where Grizzlies Roamed the Canyons, *inspired this work.*

CONTENTS

ACKNOWLEDGMENTS

The author would like to thank the multitude of people who helped make this book a reality, especially husband and proofreader extraordinaire, Tim Robinson. Thanks also go to Los Altos History Museum executive director, Laura Bajuk, for allowing me to take time off of work to research material for the book, and to San Lorenzo Valley Museum executive director, Lynda Phillips, and to the museum board of directors for their support, especially Ronnie Trubek, who offered the use of her extensive postcard collection. The majority of the images in this book are from the collection of the San Lorenzo Valley Museum, and exceptions are duly noted in the caption of the image. Thanks also to the members of the Santa Cruz Museum of Art and History Researchers Anonymous group for their support and advice, especially Randall Brown.

Many hours were spent at the Santa Cruz Genealogy library located in the Santa Cruz public library, central branch, pouring over microfilm of historical newspapers the *Mountain Echo*, the *Santa Cruz* (daily and weekly) *Surf*, and the *Santa Cruz Sentinel*. Thanks to the Santa Cruz Genealogy Society for staffing and maintaining the library.

Access to online historical *San Jose Mercury* newspaper articles was obtained through the Santa Clara County library system.

Authoritative works consulted include *A Time of Little Choice* by Randall Milliken; *Big Basin* by Alexander Lowry and Denzil Verardo; *California Powder Works, a Self-Guided Walk* by Barry Brown; *Central Coast Railways* by Rick Hammon; *Coast Redwood*, editors John Evarts and Marjorie Popper; *Going to School in Santa Cruz County* by Margaret Koch; *Historic Homes of Boulder Creek* by Barbara Kennedy; *Lime Kiln Legacies* by Frank A. Perry, Robert W. Piwarzyk, Michael D. Luther, Alverdo Orlando, Allan Molho, and Sierra L. Perry; *The Birth of California Narrow Gauge* by Bruce MacGregor; *Santa Cruz County California, Illustrations Descriptive of its Scenery with Historical Sketch of the County* by Wallace W. Elliott; and *Where Grizzlies Roamed the Canyons* by Nancy McCarthy.

INTRODUCTION

Prior to 1769, the Ohlone were the only peoples to inhabit this area. Their population once numbered 10,000 or more with several hundred villages in and around Santa Cruz. Many of the Ohlone villages moved from place to place taking advantage of seasonal sources of food such as game, fish, fruits, berries, and acorns. Village populations ranged from 50 to 500 with smaller seasonal villages.

There were at least two Ohlone tribelets associated with the San Lorenzo Valley. These were the Sayanta living by Zayante Creek, and the Achistaca living in the vicinity of Boulder Creek and Riverside Grove. These tribelets, or villages, were two of around eight in the Awaswas language group.

In 1769, the Portola Expedition discovered and named the San Lorenzo River, and gave the name Costaños, meaning "coast people," to the Ohlone people.

In 1791, Mission Santa Cruz, or Holy Cross, was established. It was the 12th Alta California mission. The first neophyte was brought to Mission Santa Cruz by her parents on October 9, 1791. She was an eight-year-old girl from the Achistaca Rancheria a few miles up the San Lorenzo River. Between 1791 and 1795, 85 members of the Achistaca tribelet and 69 of the Sayanta tribelet were baptized at Mission Santa Cruz.

In 1797, the town, or pueblo, of Villa de Branciforte was established just across the San Lorenzo River from the mission. With the establishment of the town, the number of neophytes living at the mission shrank from a peak of about 500 by over 200 in just two years. With a dwindling population through flight, and death from disease and maltreatment, the mission population was the smallest of the 21 missions. After Mexico won independence from Spain in 1821, it could not afford the missions. In 1834, Mission Santa Cruz was one of the first to be secularized.

Jose Bolcoff was one of the officials responsible for the secularization of the land, buildings, and animals. Tragically, a smallpox epidemic then decimated the native population, whose numbers fell from around 300 to just 71. Land possession was not a concept they understood, and many who did not want to become farmers tried to return to their "old ways." So, the land was sold to ranchers and the few remaining Ohlone were driven away.

Thus began the period of the Mexican land grants. The San Lorenzo Valley was a wilderness; the canyon was dangerous, inhospitable, and almost impassable. Those who chose to settle here had to forge their own paths through the steep terrain. The canyon was also inhabited by large numbers of grizzly bears.

From the early 1830s, foreigners from the east began to arrive. Under Mexican rule, land could only be owned by Mexican citizens. Many of these new arrivals would become naturalized citizens, often though marriage. Three land grants were awarded in the San Lorenzo Valley—Rancho Zayanta, Rancho Cañada del Rincon en le Rio San Lorenzo, and Rancho La Cabonera.

Rancho Zayanta was granted to Joaquin Buelna in 1834. He had been an alcalde of Villa de Branciforte; however, he let his claim lapse in 1836, giving his rights to Ambrose Tomlinson and

Job Francis Dye, who were renting the land for a gristmill and a distillery. Tomlinson sold out to Joseph Ladd Majors, who subsequently sold his interest to Dye. In 1840, with rumors of a potential revolution, Dye's property was confiscated. In 1841, it was acquired by Majors, who also acquired the adjacent Rancho San Augustin (today, Scotts Valley).

Majors had arrived in California around 1835. He married Maria de los Angeles Castro, the daughter of Joaquin Castro, a judge and alcalde of Villa de Branciforte. Majors was baptized a Catholic and became a naturalized Mexican citizen. He would later sell Rancho Zayanta to Isaac Graham, who had arrived around 1833 and erected what was purported to be the first sawmill in California in the vicinity of Paradise Park. Graham had refused to become a naturalized citizen and was one of the 52 Americans and British who were arrested in 1840. Juan B. Alvarado, governor of California, and José Castro stated they had been informed that Graham was going to raise a band of men to murder every Mexican and Californian over seven years of age. A few men of influential families, such as Majors, escaped imprisonment. Graham and the others were held for over a year. After his release, Graham returned to the Valley. The US government eventually compensated some of the interned, since they had done no wrong, and there was a treaty between the two countries. Along with Peter Lassen, Majors, and Frederick Höeger, Graham erected the first water-powered sawmill in California.

Rancho La Cabonera was granted to William Thompson (alias Buckle or Bocle) in 1838. Thompson had left the family home in England for the high seas and the Americas. When the family stopped receiving news from William, his brother Samuel left in search of him, not knowing where he might be, and after giving up and settling in Monterey, he by chance met William in Santa Cruz.

Rancho Cañada del Rincon en le Rio San Lorenzo was granted to Pierre Sainsevain, a Frenchman, in 1843. In 1859, a large section of the rancho was traded to the Davis and Jordan Lime Company for their coastal steamer. In 1860, Henry van Valkenburgh purchased a portion of the rancho from Isaac Davis and Albion Jordan and established the San Lorenzo Paper Mill. There was some confusion over the boundaries the rancho shared with Rancho La Cabonera, and Davis and Jordon deeded the Paradise Park tract in Rancho Cabonera to the California Powder Works. In 1865, Henry Cowell purchased Jordan's half of the lime company. After Davis's death in 1888, Cowell purchased the remainder. The boundary dispute went to the US Supreme Court in 1894.

In the suit, California Powder Works v. Davis et al., the courts ruled that there had never been a land grant to William Bocle in 1838 because the documents were fraudulent and actually dated 1848. They also stated that Bocle was not a Mexican citizen at that time, but a British subject, and therefore not eligible for such a grant.

During the winter of 1845, future military governor and state senator, explorer John Charles Frémont, came to California funded by the US government. Americans believed that it was the destiny of the United States to expand westward across the whole continent. It was during that winter that Frémont, while undercover, allegedly spent the night in a tree at Henry Cowell Redwoods State Park. He was discovered by Mexican authorities and ordered to leave, which he did. After the United States declared war against Mexico in May 1846, Captain Frémont returned, leading the US Army and taking control just days after the Bear Flag Revolt in Sonoma, where California Americans had claimed independence from Mexico. The Mexican-American War ended in February 1848, and California was ceded to the United States. The treaty ensured that the Mexican land grants would be honored.

The enormous natural resources of California and especially the San Lorenzo Valley were about to be discovered, harvested, and exploited. Following the gold rush and statehood, thousands flocked west, and between 1850 and 1860, the population of the Valley grew substantially. With new developments in photographic techniques, this story can continue with pictures; after all, a picture is worth a thousand words.

One

TAMING THE
WILD CANYON

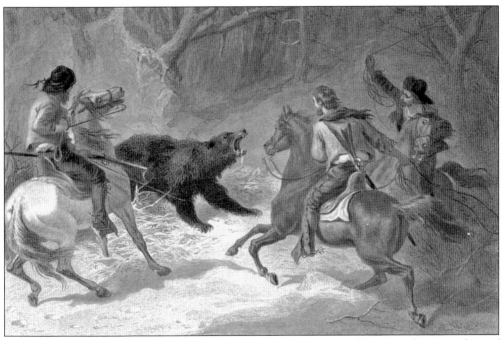

In the mid-1800s, the Santa Cruz Mountains were a wilderness and home to large numbers of grizzly bears. Human confrontations with the animals resulted in death or serious injury, such as the 1854 infamous encounter between Charles "Mountain Charlie" McKiernan and a grizzly while out deer hunting with a friend. Although he survived the attack, Charlie was inflicted with a critical injury to his head, leaving his brain exposed and his face disfigured. One of the last grizzlies to be seen in the Santa Cruz Mountains was killed by Orrin Blodgett on his Ben Lomond mountain ranch in June 1885. (Courtesy of the Library of Congress.)

ART. 8. These articles of agreement to be binding on the contracting parties when ratified and confirmed by the President and Senate of the United States of America.

In testimony whereof, the said parties have hereunto signed their names and affixed their seals upon the day and date above written.

REDICK McKEE,	[SEAL.]
G. W. BARBOUR,	[SEAL.]
O. M. WOZENCRAFT.	[SEAL.]

For and in behalf of the Si-yan-te tribe:

TRAI-PAX-E, chief, his x mark.	[SEAL.]
HABITO, his x mark.	[SEAL.]
CO-TOS, his x mark.	[SEAL.]

1084 PART IV.—TREATY WITH THE SI-YAN-TE, ETC., 1851.

E-LI-UM, his x mark.	[SEAL.]
AN-GOT, his x mark.	[SEAL.]
HO-MO-LUCK, his x mark.	[SEAL.]
PE-TE-LA, his x mark.	[SEAL.]
MA-LA-TIA, his x mark.	[SEAL.]
A-WAS-SA, his x mark.	[SEAL.]

For and in behalf of the Po-to-yun-te:

RAII TIS TA, chief, his x mark. [SEAL.]

In 1851, Sayanta people walked across California to the Sierra Nevada to Camp Fremont, near the Little Mariposa River, to sign Treaty M. Nine members of the tribelet including Chief TRAI-PAX-E signed the treaty, but it was never ratified. In his book *Sam Ward in the Gold Rush*, Ward wrote of the chief, "He was more dusky in hue and spare of flesh, with a meekness and humility of manner which almost deepened into chronic melancholy. No episode of Mission flesh pots and scarlet kerchief had interrupted with enervating influences the sad monotony of his life struggle to keep together the small remnant of his once powerful tribe. The advent of the whites, and the comforts which they bartered for gold, had passed over his existence like sunshine over the sorrows it cannot dispel. I became subsequently greatly attached to this rare representative of savage self respect, honesty, and sensitive good faith; nor do I remember a more striking proof that the great Creator has planted all the elements of moral grandeur in the natural and unredeemed man." (Courtesy of Oklahoma State University.)

Resolved, That the Senate do not advise and consent to the ratification of the treaty made and concluded on the nineteenth day of March, in the year eighteen hundred and fifty-one, at Camp Fremont, near the Little Mariposa River, in the State of California, between Redick Mc-Kee, George W. Barbour, and Oliver M. Wozencraft, commissioners appointed by the President of the United States to treat with the various tribes of Indians in the State of California, of the one part, and the chiefs, captains, and head men of the Si-yan-te, Pó-to-yan-te, Co-co-noon, Apang-as-se, Aplache, and A-wal-a-che, tribes of Indians, of the other part.

Resolved. That the Senate do not advise and consent to the ratifica-

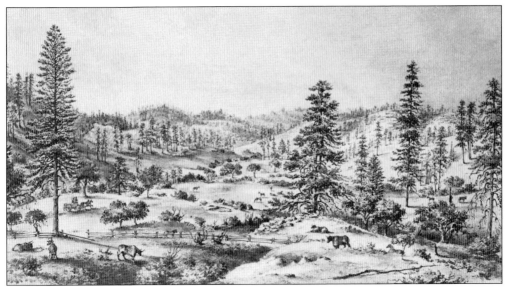

In 1864, Edward Vischer drew this scene of the Zayante area entitled "Scene on the Sayante. The late Captain Grahams Ranch." Isaac Graham had passed away in San Francisco just a few months prior in 1863. The view looks south towards the "Giant Grove from D. Rice's" property. David M. Rice was the husband of Matilda Jane Graham, Isaac Graham and Catherine Bennett's daughter. Shortly thereafter, ownership of the Zayante ranch was transferred to politician and lawyer Edward Stanly. (Courtesy of Special Collections, Honnold/Mudd Library, Claremont University Consortium.)

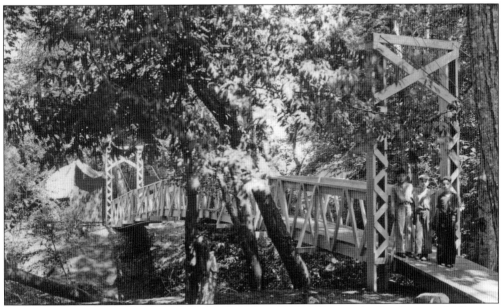

According to local folklore, the last of the Zayante people to live in the San Lorenzo Valley was Twaneeya Ware, wife of William Ware. She lived out her life in a cabin overlooking Zayante Creek. When she died, she was buried at Felton Grove. The bridge at Felton Grove over Zayante Creek is pictured here. (Courtesy of the Ronnie Trubek Collection.)

In Santa Cruz County gold has been found at various times and in varying quantities, but no systematic and energetic effort has ever been made to develop this resource of the county. A cañon known as Gold Gulch shows color in almost every part of it, and wages have been made with a pan and shovel in this locality in days agone. Many years ago a huge bowlder was discovered in this cañon, from which was extracted $35,-000 in gold. Whether this bowlder was detached from a lead in the immediate vicinity, or whether ages ago it was broken from the mother lode in the Sierras, and ultimately found its way here, is a question that has not been determined. But certain it is that a gentleman by the name of Stribling has located a quartz mine a few miles northwest of Santa Cruz, and has developed it to that extent which proves that it is a valuable property. Without entering into the details of assays, I may say that the lead is clearly ·defined, the ore easily milled, and the percentage of gold high enough to make the mine profitable to Mr. Stribling, although operated upon a limited scale. The gold is of exceedingly fine quality, and, in the opinion of those who have investigated the mine, including an expert from the State Mining Bureau, the property is valuable, and only awaits development to become profitable.

This excerpt is from the 1892 *History of Santa Cruz County* by Edward Sanford Harrison. It is known that by 1853, there were miners working gold claims on Ben Lomond Mountain. In 1855, Gold Gulch was reported to be yielding $3 to $10 per day. Several mining companies formed, such as the Empire Gold and Silver Mining Company, which incorporated in 1863. The value of the gold extracted from the infamous boulder mentioned in the extract varies in different accounts, but the sum was significant.

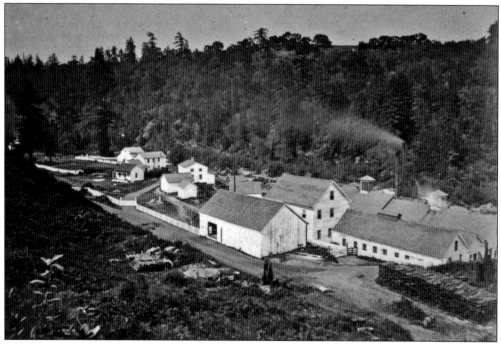

The San Lorenzo Paper Mill was established in 1860 by Henry van Valkenburgh. He was killed shortly after by a falling tree. The mill was auctioned in 1862, after which it changed hands several times in quick succession. The mill was lost to fire in 1867, but was rebuilt and operated under the direction of John Sime until 1872. It produced straw paper, newsprint, and wrapping paper, producing around 230 reams of wrapping paper per day in 1867. (Courtesy of the California Society of Pioneers.)

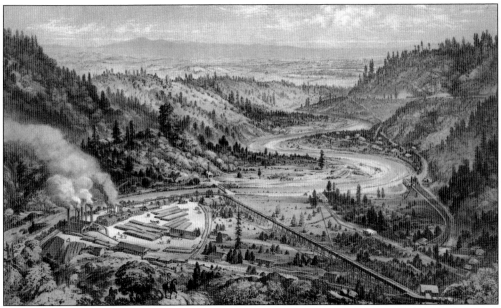

The California Powder Works was established in 1861. In 1863, it purchased the Paradise Park tract in Rancho Cabonera. The location was chosen for the manufacture of black powder because of its proximity to three important resources—timber, water, and the harbor. In 1872, the works also acquired the adjacent paper mill property. (Courtesy of the Library of Congress.)

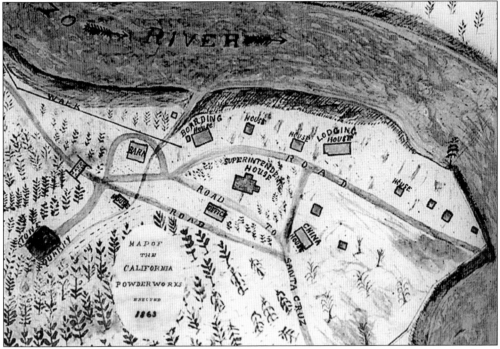

The powder works operated in the lower San Lorenzo Valley from 1863 to 1914. This is an 1863 hand drawn map of the California Powder Works showing the administrative office, the superintendent's house, lodging and boardinghouses, and the china house, where the Chinese workers were segregated from the other employees. (Courtesy of the Santa Cruz Museum of Art and History.)

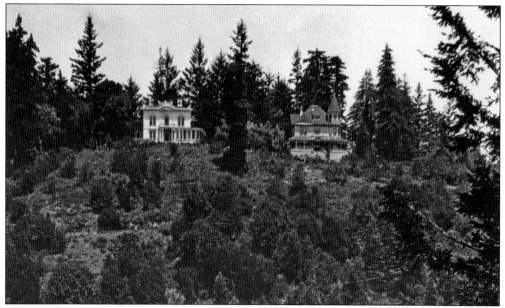

Bernard Peyton was the second superintendent of the powder works. His Italianate home (left), and his son William's Queen Anne–style home (right) stood on the hilltop overlooking the works below. Bernard Peyton, his wife, Estelle, and their six children lived in the mansion designed by Bernard and built by John Morrow, a well-known local contractor. William Charles Peyton, Bernard and Estelle's third son, married Anna Rodgley du Pont in 1894. The DuPont Corporation had acquired an interest in the California Powder Works in 1868 and, in 1903, bought a controlling interest. In 1906, the name of the company was changed to E.I. du Pont de Nemours Powder Company and in 1912, to the Hercules Powder Company.

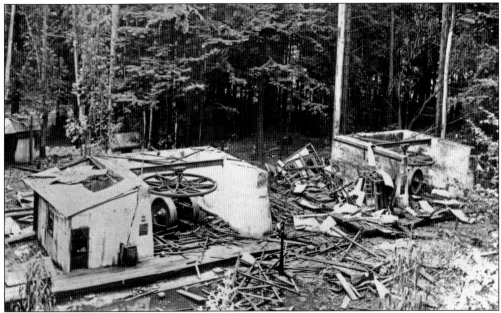

Manufacturing powder was inherently dangerous, and there were many explosions, often in the wheel mills, which combined the ingredients to create the powder. One of the worst was in 1898, when 13 men and boys were killed and 25 were injured. The cause of the explosion was never discovered. Another, pictured here, occurred in October 1905, when three wheel mills "went up."

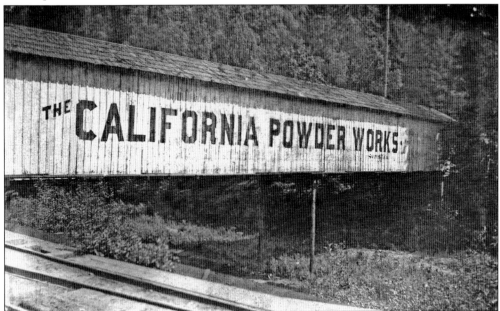

The California Powder Works covered bridge was completed in 1872 by the Pacific Bridge Company of San Francisco. At the time of its construction, it was the longest single-span bridge in Santa Cruz County at a length of 164 feet. The bridge is a Smith patent high truss design. It was built wide, sturdy, and high to simultaneously accommodate both wagon traffic and cars on a narrow gauge track. (Courtesy of the Francis Carney Collection.)

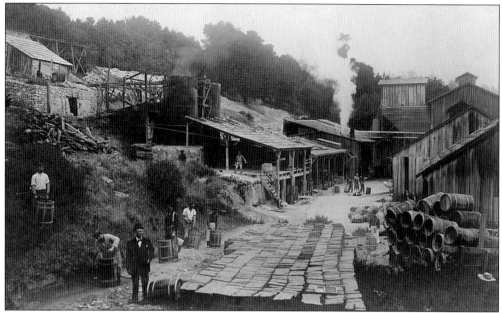

Two successful lime companies in Santa Cruz County were the Davis and Jordan Lime Company, which was later owned by Henry Cowell, and H.T. Holmes companies. The works were located along Bull and Bennett Creeks, west of Felton, on Laguna Creek, and in the town of Felton. Pictured here is the Holmes lime works at Felton in 1908. In that year, the Felton plant produced about 180,000 barrels of lime. (Courtesy of Santa Cruz Museum of Art and History.)

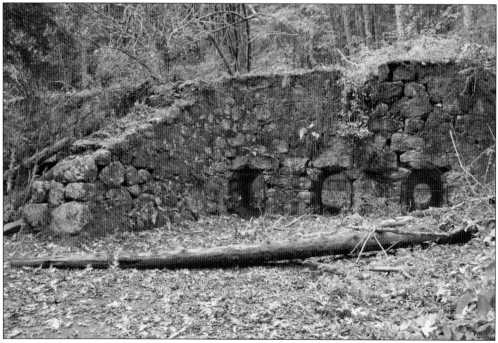

These are the remains of the kilns of the I.X.L. ("I excel") Lime Company on Fall Creek, west of Felton, in what is now part of Henry Cowell Redwoods State Park. The company, which was founded in 1874, was purchased by Henry Cowell in 1900. It ceased production around 1919.

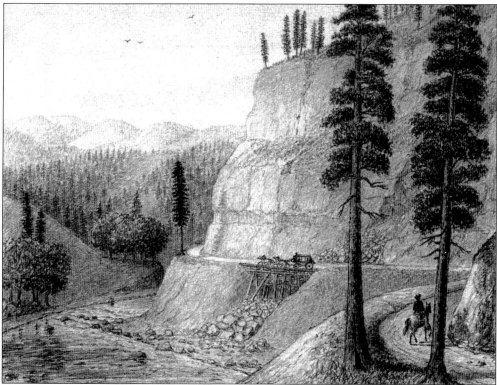

Finally, despite much political maneuvering by Davis and Cowell, the road along the west bank of the San Lorenzo River between Santa Cruz and Felton opened in 1868 to much fanfare. It was an engineering masterpiece, having been cut along the canyon wall sometimes hundreds of feet above the water. Money to build the road was raised by subscription, and money to maintain it was to be raised through tolls. (Courtesy of the Bancroft Library, UC Berkeley.)

In June 1871, the Maclay Turnpike officially opened. The toll road ran 11 miles from Saratoga Gap to meet the road that ran four miles north of Boulder Creek. Lumber could now be shipped over the mountains to the Santa Clara Valley. In 1872, Joseph Peery leased the toll road from Maclay, and the following year a stagecoach route was established, though it took two days to make the journey from Santa Clara to Felton.

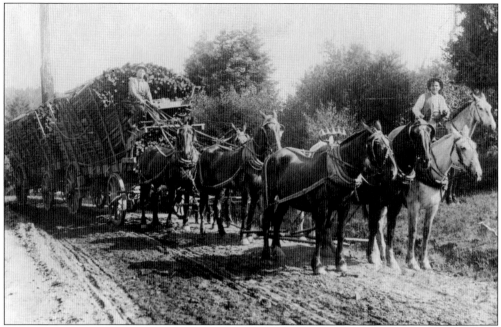

In the early years, lumber was hauled from the mills in huge wagons drawn by oxen, horses, or mules. These enormously heavy wagons made their way out of the San Lorenzo Valley down the steep and dangerous trail known as "Graham's Grade" (now Graham Hill Road) to the wharf in Santa Cruz. There, the cut lumber was loaded aboard waiting ships.

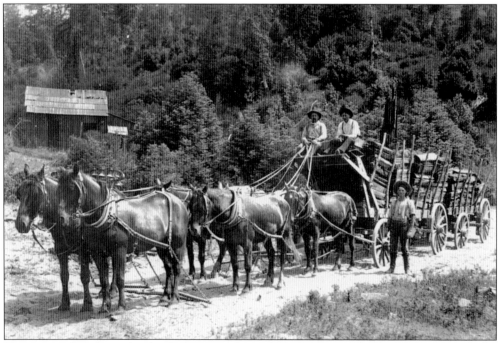

A wagon and trailer with a load of grape stakes is being transported. The teamster is Charles Johansen. When the grades were very steep, such as Jameson Canyon, heavy drags were used behind the wagon to keep the teams of horses from being run over by the heavy loads.

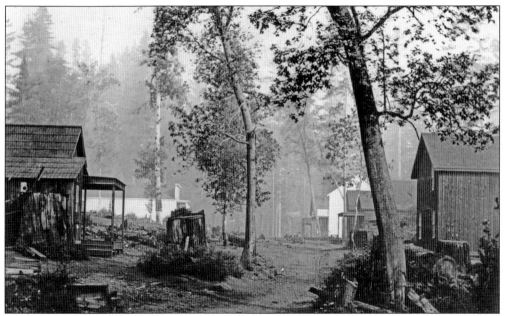

In the 1870s, besides scattered settlements there were two villages, Felton and Lorenzo. Lorenzo, pictured here, was founded by Joseph Wilburn Peery. It was often described as at the headwaters of the San Lorenzo River or near the summit of the mountains; it had a hotel, a store, a few dwellings, and Peery's sawmill, known as Silver Mills.

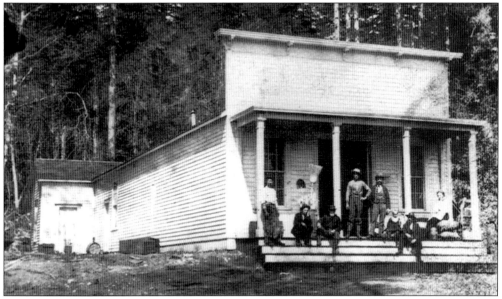

Pictured here is Charles Cottrell's general store in Lorenzo. In 1874, Cottrell succeeded Joseph Peery as the Boulder Creek postmaster. When he moved the post office from Boulder Creek to Lorenzo, about one mile, many Boulder Creek residents were furious: not only was it inconvenient, but liquor was sold on the premises. A petition was drafted to the postmaster general in Washington, which 72 residents signed, demanding the post office return to Boulder Creek. It returned in 1876, when David Hossack replaced Cottrell as postmaster. (Courtesy of UCSC Special Collections, Dan Matthews Collection.)

Capital Stock,

No. 119

202 Shares.

$500,000.

SAN LORENZO

Flume and Transportation Co.

Incorporated,
August 26, 1874.

SAN JOSE, Santa Clara Co. Sept 30 1879

This Certifies That A. E. Davis

is the Owner of Two hundred + two ————— Shares

5,000 Shares,

of the Capital Stock, of the SAN LORENZO FLUME AND TRANSPORTATION COMPANY, transferable on the Books of the Company, subject to the provisions of the By-Laws, by endorsement hereon and surrender of this Certificate.

$100 each.

Edward Bosqui & Co., Printers.

SECRETARY. PRESIDENT.

Efficiently transporting the cut lumber to Santa Cruz soon became a high priority. Initially, there were plans to flume the lumber from the headlands of the San Lorenzo Valley right down to the wharf in Santa Cruz. Because of the lack of feeder creeks in the lower valley it was decided instead to flume from Boulder Creek to Felton and build a narrow gauge railroad from the flume terminus in Felton to the wharf.

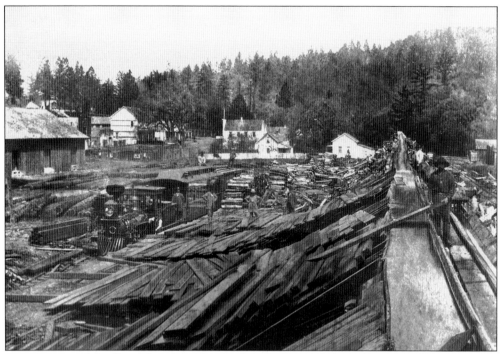

Construction of the flume from Boulder Creek to Felton and the railroad between Felton and Santa Cruz proceeded in parallel. The flume terminus in Felton is pictured here. The railroad was formally opened in October 1875. The train left the wharf in Santa Cruz carrying several hundred people to Felton where many more had assembled. They took them on board and journeyed back to the toll house where they disembarked for a celebration and picnic. By the end of October, the flume was "bringing down considerable lumber." (Courtesy of the California State Library.)

Two

TO HARVEST A REDWOOD

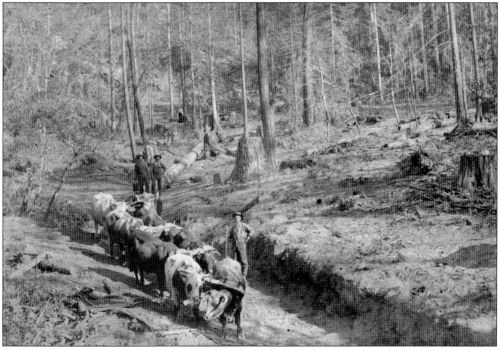

By 1857, there were 10 lumber mills in the county, five water powered and five steam powered, and by 1868 there were 22 lumber mills, 12 water-powered and 10 steam-powered, plus nine shingle mills. Oxen were used to transport the lumber to the mills.

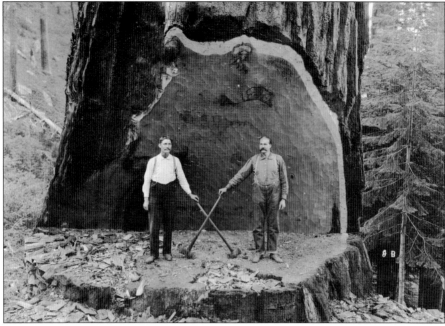

Early loggers would fell the redwoods by chopping through them with an axe. The choppers, as they became known, would leave the larger trees in favor of the smaller, easier to fell redwoods. Choppers required axes with longer handles and heavier heads for felling these large trees. Wielding a 42-inch-long axe with a four-pound double head was muscle-building work. Above, two "choppers" stand in the undercut of a tree. Below, the same tree is clearly a tourist attraction. In the undercut of the upper photograph is inscribed the date July 9, 1905.

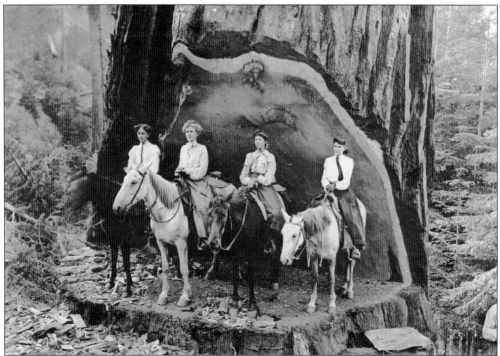

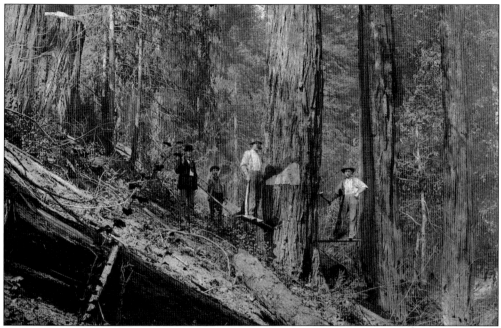

Because large redwoods can be very wide at their base and because the wood at the base can be very hard to cut though, the choppers would cut notches higher up the trunk of the tree into which they drove springboards, on which the choppers would stand to make the cuts. The fellers here are identified as Kay Butler (left) and Gus Olsen (right).

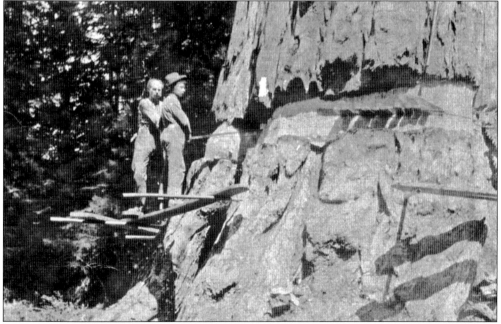

After the undercut had been made, a long felling saw was used to make the back cut. As the cut was made, steel wedges were driven in to keep it open and to stop the saw from jamming. As shown here, planks were sometimes laid across the springboards to create a platform on which the loggers could work.

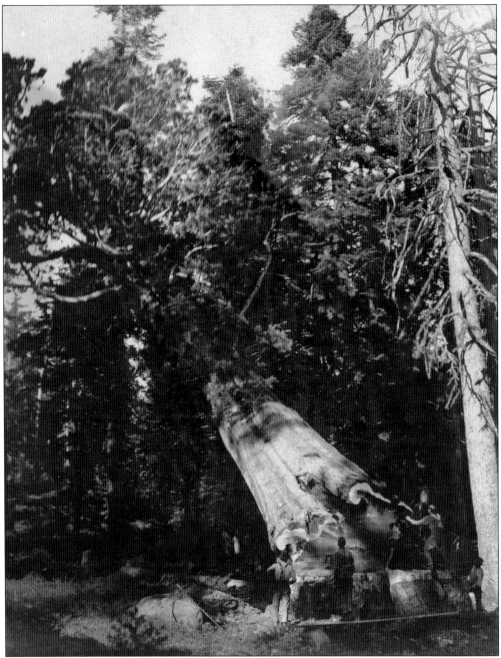

To help steady the saw, as the back cut is made, two holes were bored horizontally into the tree, about two inches in depth. Wooden pins were then driven into these holes, on which the saw was rested. Notice the auger, used to make such holes, leaning on the rock beside this falling tree. Four men have felled this giant, taking care in choosing the direction in which it would fall such that the surrounding vegetation would provide cushioning and so it would not shatter as it hit the ground.

This photograph was taken at Oil Creek Mill. Just like the horses and mules, the oxen also needed to be shoed; this was no easy task. Oxen find it difficult to stand on three legs so the animals were hoisted in a harness, and their head was restrained with a rope in order that the farrier could more easily perform the undertaking. Since their hooves are cloven, two shoes are needed for each hoof.

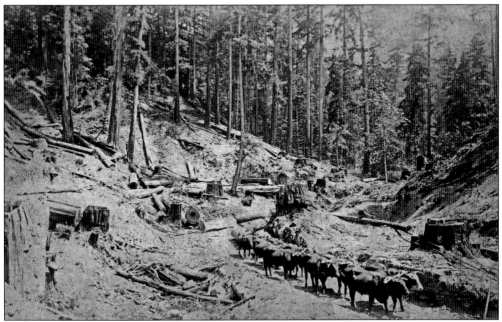

Pictured here is a team of oxen transporting felled lumber to the Hubbard and Carmichael mill, also known as Oil Creek Mill. The mill was named after the creek on which it was located. Oil Creek was a prime fishing destination; in the early 1900s, the trout caught in the creek were all reputed to be over 10 inches long.

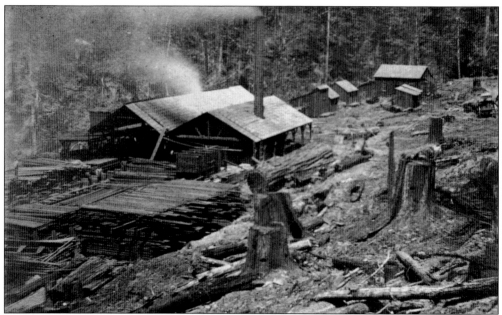

In 1875, the Felton Flume and Transportation Company's mill was constructed at the head of the flume to produce flume sections. It cost $12,000 to construct and employed 25 men. Ephraim B. Morrell was appointed as its superintendent. Joseph Lane was awarded the contract for cutting down the lumber to supply the mill. The capacity of the mill was 30,000 feet per day. (Courtesy of UCSC Special Collections, Dan Matthews Collection.)

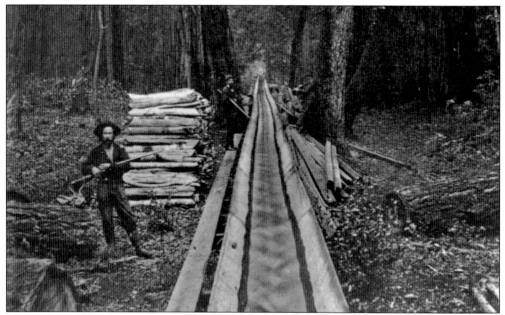

This photograph depicts a flume walker at work. He is in the background with a pole or pickaroon tucked under his arm used for freeing lumber jams. Several men were employed to walk the flume, including Billy Dool, who later became a warden at Big Basin State Park. Near the flume is a pile of "split stuff" ready for transport. On the left in the foreground, a hunter poses with the head of his kill, a deer, draped over a nearby log.

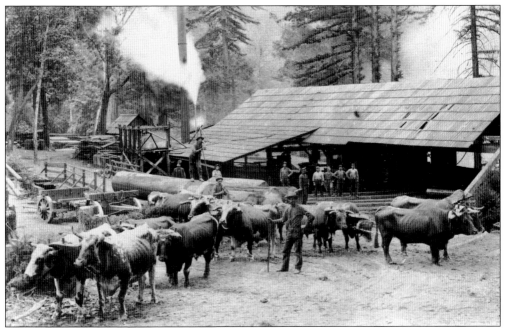

The Harmon mill, pictured here, was on Bear Creek Road. Twins Austin and Oscar settled here from Maine in the 1860s, first working at Peery's mill and then obtaining land grants along Bear Creek. Known as the Alameda Lumber Company Mill, it burned to the ground in 1890 along with several thousand cords of wood. The twins are credited with pioneering the construction of a toll road to the summit. This would become Bear Creek Road.

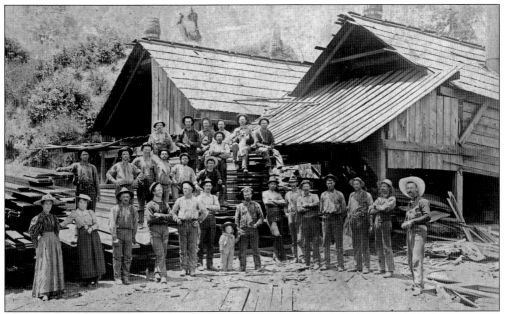

This is one of the Cunningham mills. James F. Cunningham is identified on the photograph at the far right. Aside from his large number of lumbering interests, Cunningham owned a hotel in Felton, served several terms as a member of the board of supervisors of Santa Cruz County, and also represented the county in the state assembly.

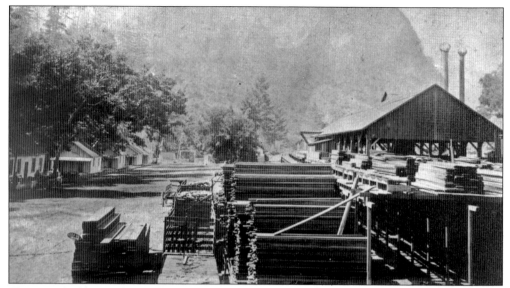

This view looks west down what is now Mill Street in Ben Lomond. The Pacific Manufacturing Company mill dominated the settlement. James P. Pierce was the president. He installed one of the first band saws in California at this mill in 1887. The library now stands in place of the far left building, which was the company store. When the settlement applied for a post office with the name Pacific Mills, it was turned down. The settlement was renamed Ben Lomond in May 1887.

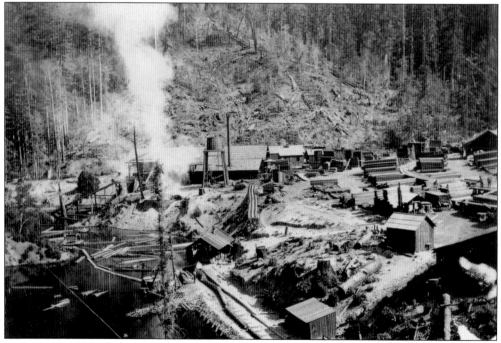

In the early 1900s, Irving Thompson Bloom's Park Mills was in operation close to the newly established California Redwood Park at Big Basin. The I.T. Bloom's timber tract was 320 acres adjacent to the southeastern corner of the park. Today, Blooms Creek runs parallel to highway 236 towards the park.

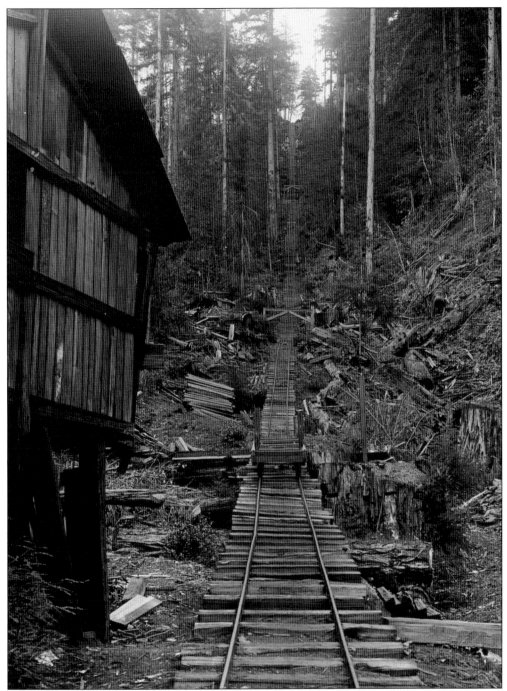

This is a photograph of the Hartman and Peery railroad tie camp taken during World War I. On the tracks towards the center of the image is a cable car. Cable cars such as this were used to haul the split stuff to the marshalling area above, where trucks would pick it up and transfer the lumber to the Southern Pacific depot in Boulder Creek.

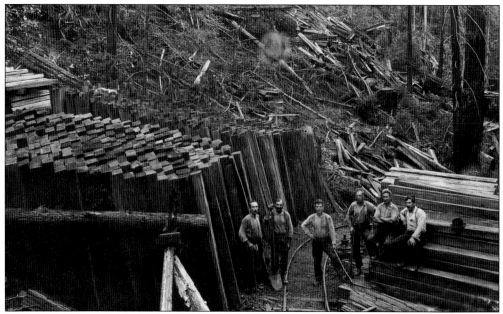

This is the Hartman and Peery railroad tie camp above Big Basin in 1917. Notice the spindle between the men. At the top of the hill was a steam hoist. The hoist's cable was wrapped around the spindle and used to hoist the cars hauling the railroad ties. Second from right is Joseph Locatelli, owner of the Italia Hotel on Big Basin Way, which would later become Scopazzi's Restaurant and Lounge.

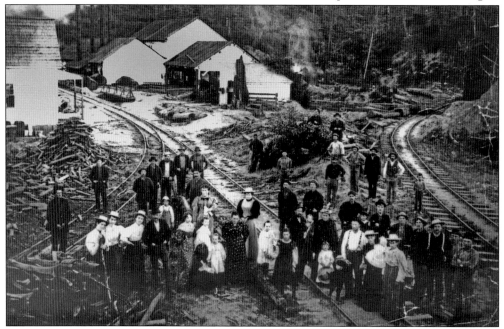

This picture of the Doughtery Mill, Riverside Grove was taken in 1895. The woman holding the baby at lower right is Annie Frykland, wife of the head sawyer at the mill, John Frykland. The baby is Ragnhild Frykland. Annie and John emigrated from Sweden in 1890. The gentleman wearing the derby hat is Bernard Doughtery. His wife-to-be, Angeline McGaffigan, is standing to his left. Patrick McGaffigan, Angeline's brother, was the superintendent of the mill.

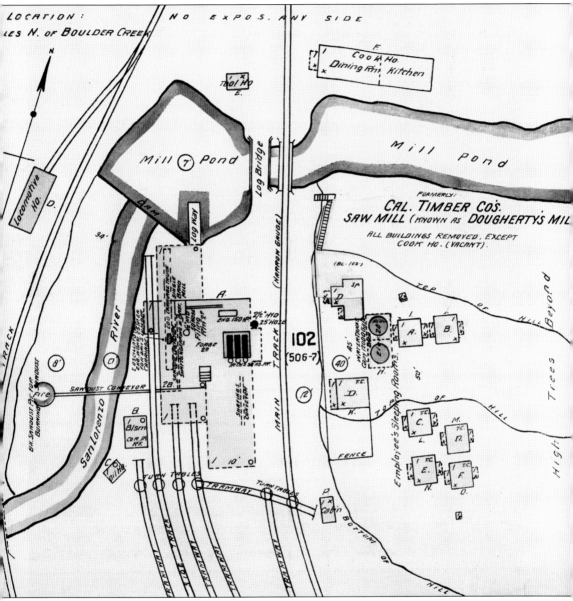

Created by Sanborn Company for assessing fire insurance liability, this map shows the extensive operations of the California Timber Company Mill, also known as the Santa Clara Valley Mill and Lumber Company mill, but better known as Dougherty's mill, just four miles north of Boulder Creek. In 1888, William Dougherty built a narrow gauge line known as the Dougherty Extension Railroad from Boulder Creek to its mill because the flume could not satisfy its production capacity. Later that year, the mill was destroyed by fire. The loss was estimated at $50,000, and the cause was unknown. Two railroad cars that were partially loaded were also lost, but one million board feet of lumber was saved.

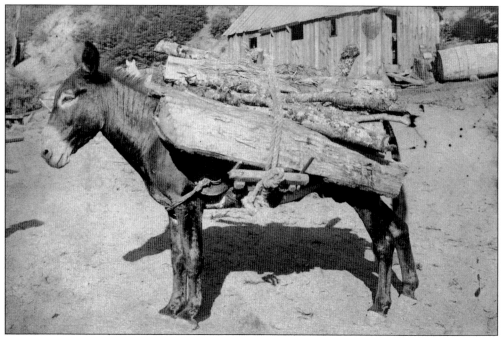

Mules, the offspring of a male donkey and a female horse, were also used to carry lumber as pictured here. Mules, with their sure-footedness, were better suited to working on the steep slopes than horses. The wood was strapped to a wooden sawbuck pack saddle tree, which straddled the animal's back.

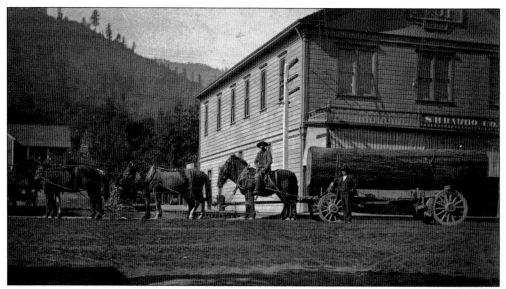

Teamster Arthur Bowden poses with his team in front of the Odd Fellows Hall on the corner of Forest Street and Central Avenue in Boulder Creek. Behind the team in the roadway is a stack of cordwood. Cordwood is wood that has been cut to a uniform length and is often used for firewood.

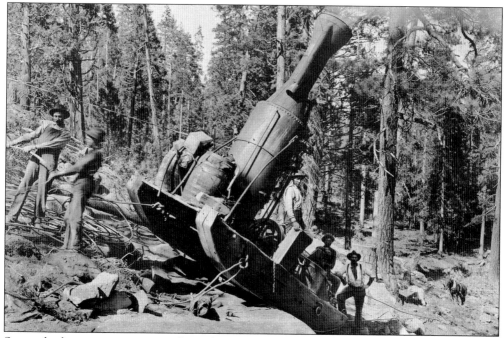

Steam donkeys, or steam-powered winches, were used to drag large logs from where they were felled to the mill or a place where they could be cut into smaller pieces. The donkey consisted of a powered winch around which was wound a cable. When the donkey was to be moved, the cable was placed around a tree or stump, and the donkey would drag itself on its wooden skids to the next location. Pictured below standing on a steam donkey with his arms folded is Finnish woodsman Johan Bjork.

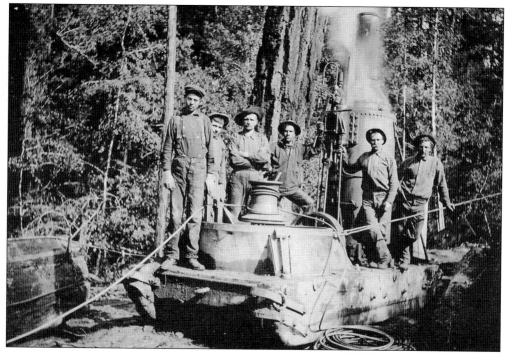

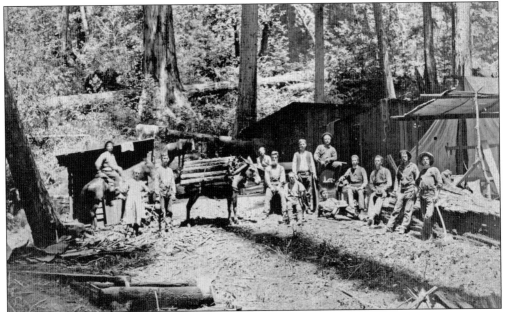

Pictured here is a tanbark operation. By 1900, 75 percent of the original tan oaks had been harvested for their bark, which was high in tannins, supplying the leather tanneries in Santa Cruz, San Jose, Santa Clara, and Redwood City. The peeling season ran from mid-May to mid-August, with trees on a shady north slope peeling later. It took at least half a day for two men to peel a large tree using a woodsman's one-edged axe.

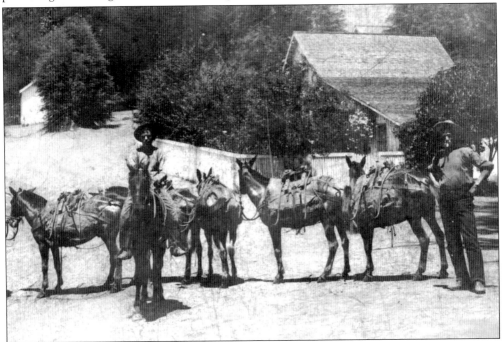

Here, a team of mules is ready for "gulching." They wear wooden sawbuck pack saddle trees on their backs to which the split stuff is attached. The gulches—deep, narrow ravines created by rainfall during the winter storms—provide a crude, natural pathway up and down the steep hillsides.

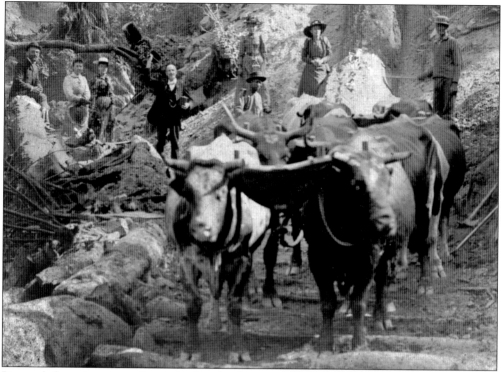

Pictured above is a team of oxen hauling lumber on a "skid road" made of logs. Often, it would be the job of the youngest member of the team, perhaps as young as 12 years of age, to keep the skid road greased to lessen the friction of the logs being dragged over them. Notice the gentleman towards the center waving his hat at the camera and the ladies in their fine clothing. In 1898 a team of oxen from Dougherty's mill hauled what was reputed to be the largest load of logs over a skid road. The record-breaking driver was Chris Iffert, and the load was 14 logs from just two trees containing almost 57,000 board feet of lumber. The caption on the postcard below states that this was the very last ox team in Santa Cruz County.

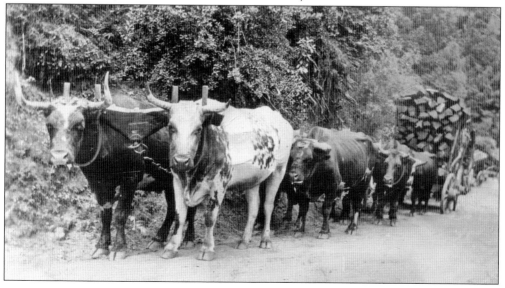

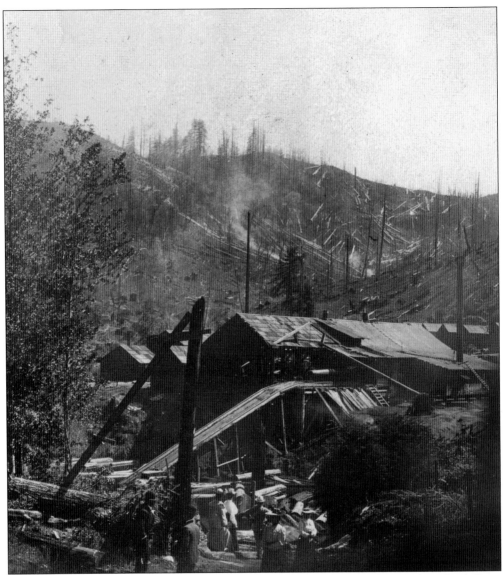

The name of this mill is unknown, but notice the surrounding forest. The area has clearly been heavily logged but there appear to be the remnants of a fire. Fires were all too common and often it was the mill equipment that started the blaze. Many mills were burned to the ground. One of the most devastating forest fires happened in 1904 and started close to Big Basin but came within just four miles of Boulder Creek. Blooms Mill was destroyed, as were homes and the Sequoia schoolhouse. Individual losses from the fire were about $35,000; several families lost practically everything they possessed. The area had been logged previously, and there was a healthy new growth of trees from five to 25 years old. "All of this young timber has been scorched and blackened until there is little sign of life left."

Three

MOVING LUMBER AND PEOPLE

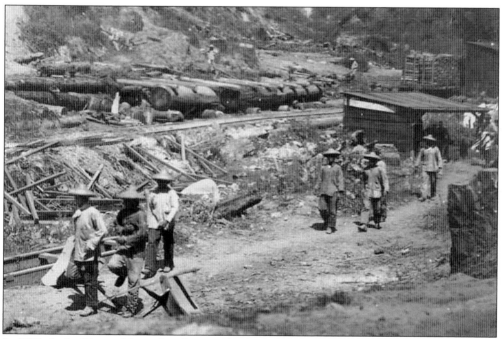

In 1879, the building of the railroad across the summit from Los Gatos to Felton was progressing slowly. A tunnel explosion in March, caused by a buildup of gas, had killed five Chinese workers. It was played down in the newspapers but it did halt work for some months. In November, a larger double explosion killed 32 Chinese workers, all at a time when the aggressive anti-Chinese movement was intensifying. In 1880, the Chinese population in Felton was 21 percent of the 271 residents, the majority being laborers for the South Pacific Coast Railroad. Unlike the white railroad employees who were housed in hotels and boarding houses, the Chinese laborers were housed in the inhospitable freight house. Pictured here are Chinese workers building the Loma Prieta Lumber Company railroad. (Courtesy of the California Historical Society, FN-32820.)

Freight rail traffic on the line from the Santa Clara Valley over the summit through Felton to Santa Cruz began in mid-May 1880. Passenger traffic began on May 23, 1880. An excursion train carrying passengers from the Independent Rifle picnic at Big Trees met with a terrible and fatal accident near the California Powder Works. For some reason train orders were changed at the last minute and a driver who had never driven the track was assigned to the run. As the engine traveled down the grade its speed increased dangerously. At a curve in the line the first car jumped the track to the left and the second to the right. Fourteen people lost their lives.

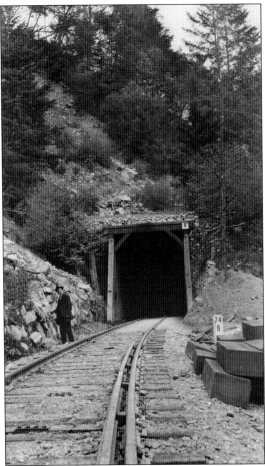

The Santa Cruz and Felton railroad line curved around inspiration point south of Felton. When the South Pacific Coast Railroad took over operation of the route, it dug tunnel No. 6, (later known as tunnel No. 5), to straighten out the line. After a storm, the tunnel entrance would often be blocked by rock falls and the face was eventually extended to mitigate this problem.

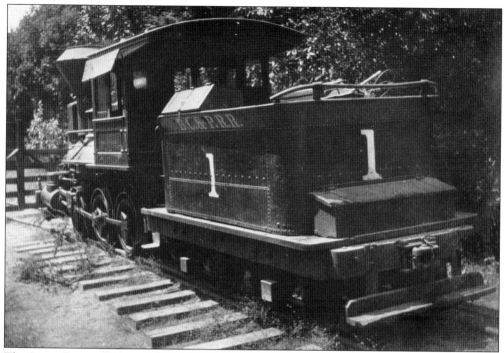

The Santa Cruz and Felton railroad company acquired two 0-6-0 locomotives from the H.K. Porter Company. The first, purchased in 1875, was known as the "Santa Cruz;" the second, purchased in 1876 and pictured here, was known as the "Felton." Later, the Felton, affectionately known as the "Dinkey" was purchased by the Santa Clara Valley Mill and Lumber Company to work on the Dougherty extension carrying lumber and freight from the Dougherty mill and from Sinnott Switch to Boulder Creek twice a day. Sinnott Switch was two miles north of Dougherty's and served the Chase Lumber Company, which was harvesting lumber in the Feeder Creek Canyon.

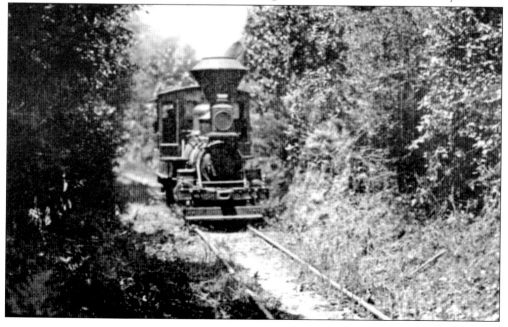

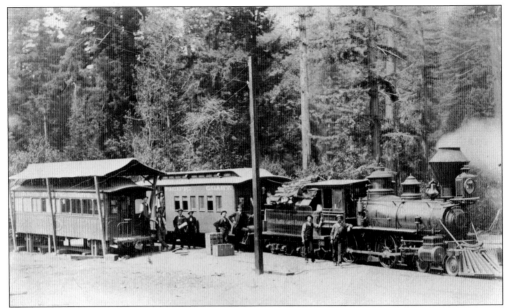

In May 1885, the South Pacific Coast Railroad Company had commenced loading freight at Boulder Creek, near the new store of James F. Cunningham. As was common practice at the time, the first depot at Boulder Creek was constructed from a disused railroad car. The Cunningham store would be acquired by James Dougherty and Henry L. Middleton.

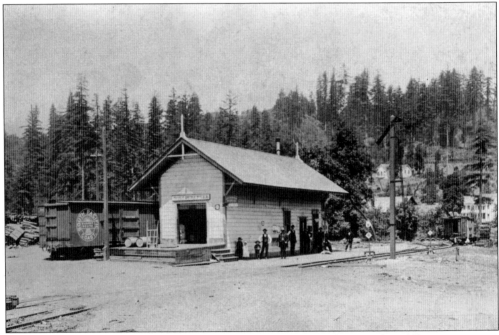

The new Boulder Creek depot was located just behind the Dougherty and Middleton store, now the fire department. Track number one runs behind the depot and track number two is in front. On the right in the distance is the Boulder Creek House on the corner of West Park Avenue.

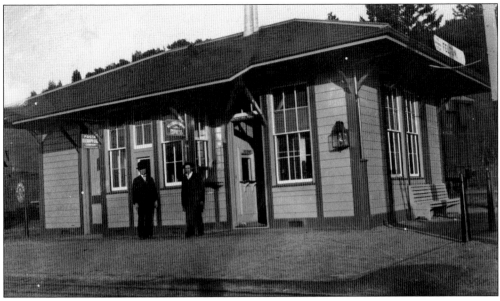

The original Felton Depot was located behind where New Leaf Community Market stands today along with the flume terminus. When the railroad from Los Gatos to Felton was completed in 1880, a new depot was constructed. The old depot was renamed "Old Felton" as shown on the map at right. In 1888, the new depot burned to the ground, and nothing was saved. The fire was considered arson, the suspects having stolen a hand car and lantern from Glenwood during the night, both of which were found the following morning thrown off the track near Santa Cruz. The rebuilt depot, pictured above, stands close to the entrance to Roaring Camp Railroad.

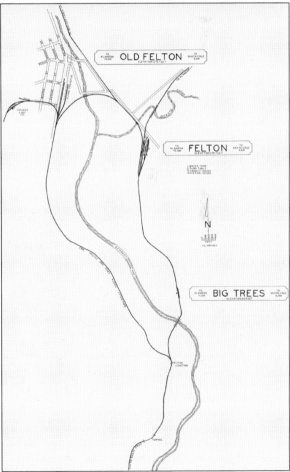

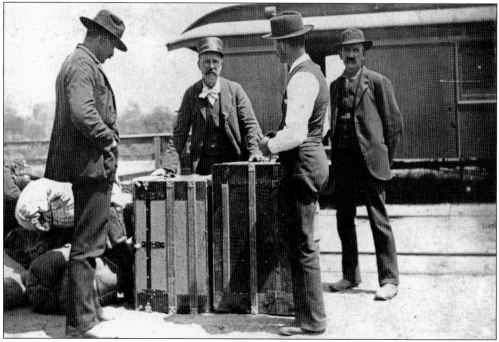

This is Felton Depot around 1902. For many years, the station agent was Joseph H. Aram, believed to be the one in the center behind the trunks. Aram worked for the South Pacific Coast and later the Southern Pacific railways for over 40 years. In his early years working for the railroad, he was in charge of the flume operations and its teardown.

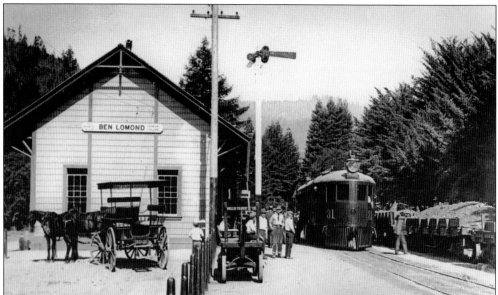

In 1910, McKeen gasoline motorcars ran on the line between Boulder Creek and Santa Cruz. One is pictured here at the Ben Lomond station. In June of that year, a terrible accident happened on the railroad bridge at "death curve" just south of Boulder Creek. The Garretty family were on their way to visit friends and were on the bridge when a motorcar approached. The wife was killed instantly, and the children were hurled to the ground.

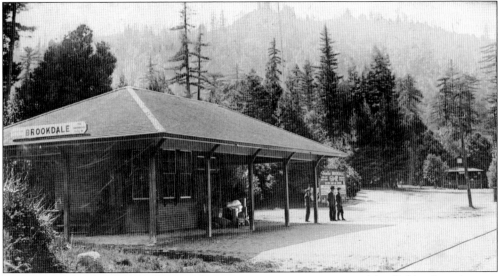

Brookdale was promoting itself as an elite getaway trying to entice wealthy Oakland residents to purchase summer homes on the Huckleberry Island subdivision. The sign behind the Brookdale depot in the background is enticing visitors to buy a lot for just $50 and up. It also boasts of Brookdale's electric lights and sewers.

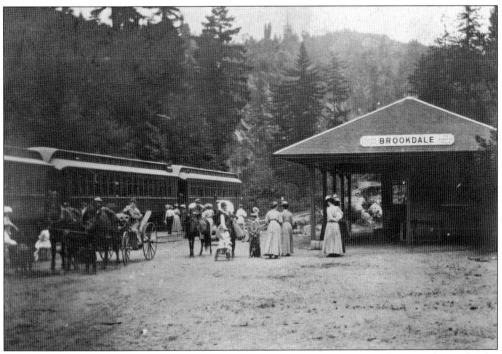

It was not until 1902 that the little village at Clear Creek was officially named Brookdale. Judge John Logan, famed original cultivator of the loganberry—a raspberry crossed with a wild blackberry—owned land around Clear Creek and had it subdivided into lots. It was to become a highly desirable place to build a summer home.

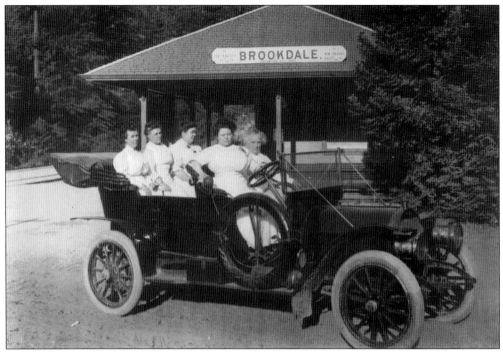

Perhaps it is ironic that the Rex ladies pose in their motorcar in front of the Brookdale station, for it was to be the rise in popularity of the automobile that would eventually cause passenger traffic on the line to diminish. Pictured are, from left to right, (first row) Harriett and their mother, Alice Locke Rex; (second row) Francis, Annie, and Attie.

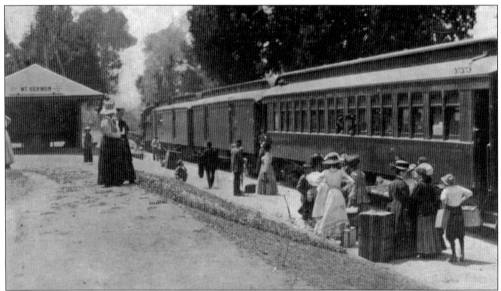

Passengers arrive at the Mount Herman train station. In 1907, the first in a series of three weekend excursions began. The fare from San Jose including hotel entertainment was just $4. The *San Jose Mercury* reported, "A goodly number of San Joseans are going down to select lots for summer cottages. Are You?" Before the property was purchased by the Mount Herman Association, the stop was known as Tuxedo Junction. (Courtesy of the Ronnie Trubek Collection.)

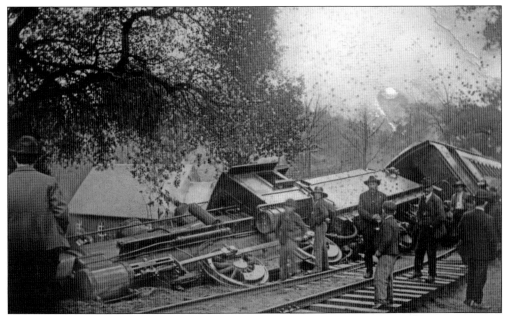

In March 1906 during a heavy rain storm, sand had been washed onto the railroad track in Ben Lomond. Although Milo Hopkins noticed the danger and signaled the approaching train with his handkerchief, the engine struck the sand, leaped off of the track, and traveled a distance of 54 feet before pitching over next to an oak tree. Notice St. Andrew's Episcopal Church in the background.

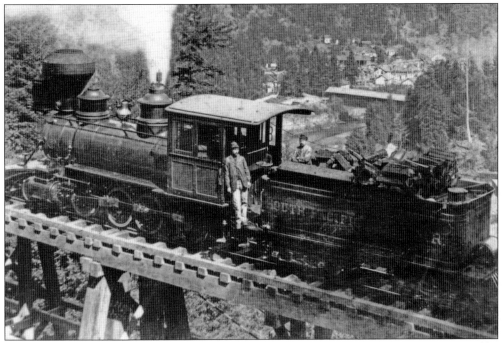

Pictured here is South Pacific Coast's narrow gauge locomotive No. 13, a 2-8-0 manufactured by Baldwin. It is on the Rincon trestle south of Felton. Below in the background is the California Powder Works. The powder works covered bridge can be seen spanning the San Lorenzo River.

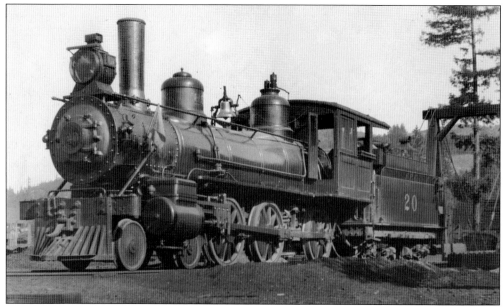

This is South Pacific Coast narrow gauge locomotive No. 20, a 4-6-0. It was built by Baldwin Locomotive works in 1887 and is thought to be the largest of South Pacific Coast's locomotives; it weighed over 70,000 pounds. It is pictured here at the end of the turntable in the Boulder Creek railroad yard.

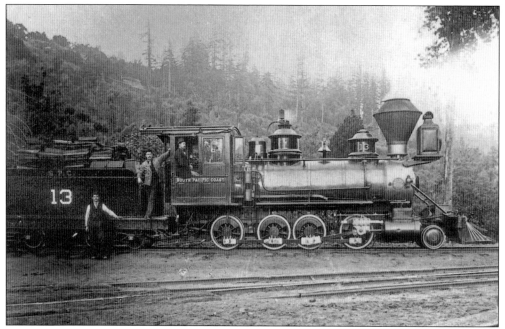

Pictured again is South Pacific Coast's locomotive No. 13 at Boulder Creek. Behind the locomotive stands a pile of split stuff ready to be shipped. In 1899, this locomotive broke the record for daily shipments out of Boulder Creek, pulling 73 loaded freight cars and a caboose. Its total length was 2,413 feet, almost half a mile.

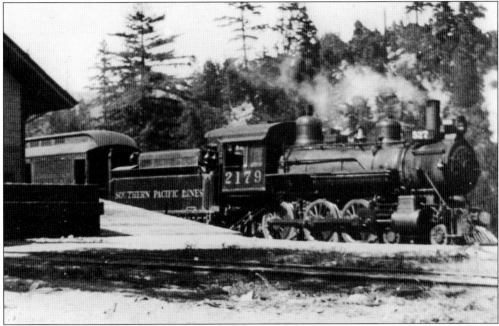

Southern Pacific Railroad acquired the South Pacific Coast line in 1887, and around 1900 began the process of standard gauging the line over the Santa Cruz Mountains and to Boulder Creek. Standard gauging the line from Felton to Boulder Creek was completed in 1907. Hampered by the 1906 earthquake damage to the Summit tunnel, standard gauging across the mountains was not completed until 1908. Pictured here is South Pacific Coast standard gauge locomotive No. 2179 at the Boulder Creek Depot.

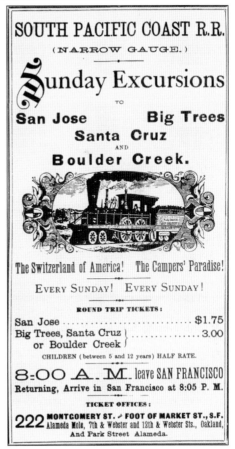

SOUTH PACIFIC COAST R.R.
(NARROW GAUGE.)

\mathcal{S}unday Excursions

TO

San Jose **Big Trees**
Santa Cruz
AND
Boulder Creek.

The Switzerland of America! The Campers' Paradise!

EVERY SUNDAY! EVERY SUNDAY!

ROUND TRIP TICKETS:

San Jose $1.75
Big Trees, Santa Cruz }.............3.00
 or Boulder Creek }
CHILDREN (between 5 and 12 years) HALF RATE.

8:00 A. M. leave SAN FRANCISCO
Returning, Arrive in San Francisco at 8:05 P. M.

TICKET OFFICES:

222 MONTGOMERY ST. ✦ FOOT OF MARKET ST., S.F.
Alameda Mole, 7th & Webster and 12th & Webster Sts., Oakland,
And Park Street Alameda.

Like many mountainous, forested regions in the west newly accessible by rail, this South Pacific Coast advertisement touts the San Lorenzo Valley as "the Switzerland of America." On May Day 1886, the *San Jose Daily News* reported, "This is a quiet day for the Garden City. It seems that about half of the population is out of town, having gone to the Big Trees and Santa Cruz or to Monterey."

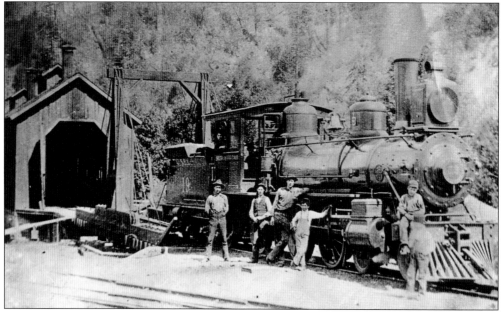

Pictured here is South Pacific Coast narrow gauge locomotive No. 19, a 4-6-0. Behind the engine and tender is the Boulder Creek engine house. The engine house was just a single stall but long enough to handle two engines.

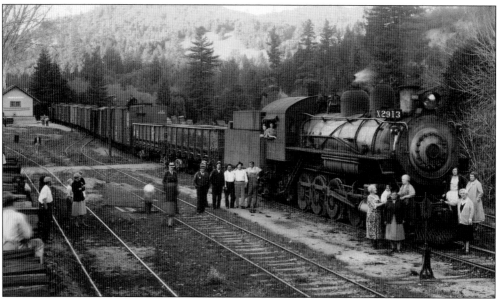

By October 1929, the train from Boulder Creek only ran to Felton. Passengers took the bus to Santa Cruz, and the Ben Lomond and Bookdale stations were closed. By the summer of 1930, all passenger trains from Boulder Creek to Felton had been discontinued and the route replaced by busses. Only one freight train per week ran if needed. By 1934, Boulder Creek was considered a premier mountain resort and was served by good roads. The need for a freight service was considered negligible and the service was discontinued. Pictured here is the last train out of Boulder Creek, which ran on January 26, 1934. The train brought boxcars that were sidetracked in Boulder Creek down to Santa Cruz.

Four

But Where Will We Stay?

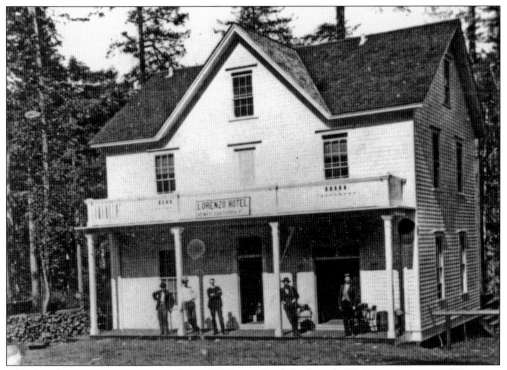

This hotel at Lorenzo was opened in 1875. It was built by Joseph W. Peery, a native of Virginia. Peery and his second wife, Mildred, arrived in Santa Cruz in the late 1860s, where she ran a restaurant, and he worked with lumber. In 1871, Peery was awarded a land grant. He laid out the town of Lorenzo, which was bounded by Harmon, West, South, and East Streets, and built a lumber mill.

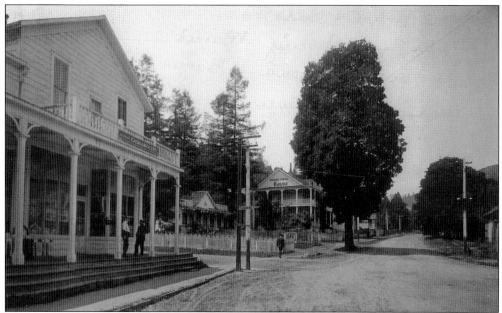

The old hotel on this site, constructed by John Henry Alcorn, was torn down in mid-1875 and "rebuilt, painted, papered and finished in fine style." The new hotel, owned by Stephen Crediford, was known as the Boulder Creek House. It was a temperance house, and in July 1875 it was reported that the lots surrounding the hotel were being laid out to form a new temperance town. It was located on the corner of West Park Avenue and Highway 9.

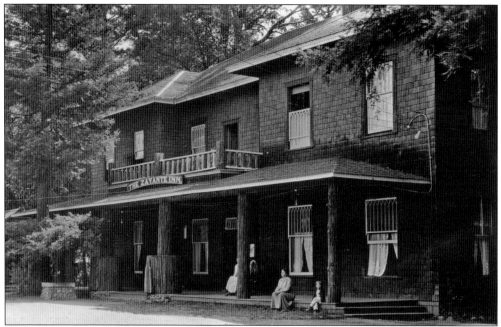

Formerly the Tuxedo Inn, the Zayante Inn and surrounding ranch were purchased in 1906 by the Mount Herman Association. The ranch, which was owned by the Artesia Development Company and Thomas Bell, consisted of about 400 acres, the inn, and summer cottages. The inn was lost to a fire in 1921. (Courtesy of the Ronnie Trubek Collection.)

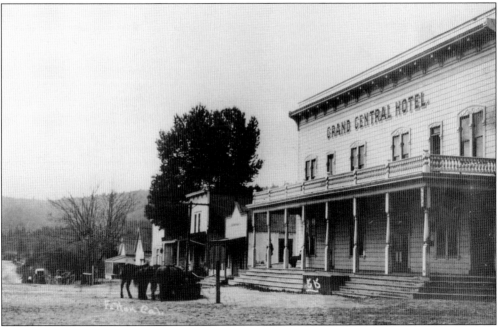

The Grand Central Hotel opened in Felton in 1889 with a grand ball. There were 50 rooms including a parlor, private reception room, a dining room, an office and bar room, a kitchen, bathroom, and numerous bedrooms with "many modern conveniences and accommodations." It was erected by Hubbard Wilson McKoy on the site of the first hotel, the Central Hotel, which had burned down.

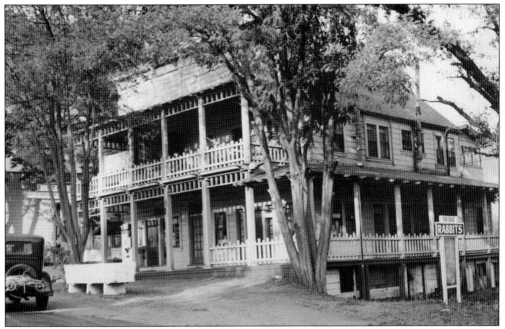

The Cremer Hotel in Felton was erected in 1876 by Thomas Cremer just north of the railroad terminus and turntable. The building still stands today. It is the only survivor of the 1888 fire, which destroyed all the other buildings on that side of Baldwin Avenue (now Highway 9), including the Grand Central Hotel. (Courtesy of the California Historical Society.)

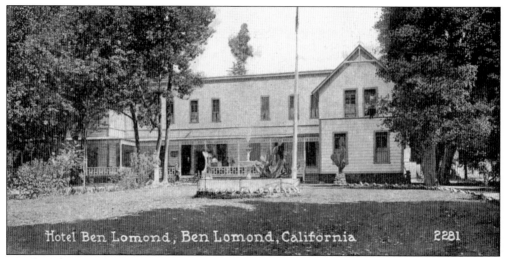

Hotel Ben Lomond, Ben Lomond, California 2281

Hotel Ben Lomond and cottages, pictured above, were described as a delightful summer resort with pine scented sea air and invigorating outdoor sports including fishing, hunting, boating, swimming, driving, riding, tennis, and bowling. It was built by James Pierce in 1889 and bought by entrepreneur Daniel W. Johnston in 1895. The hotel was rebuilt and refurbished in 1905 by new owner Frederick A. Cody. The 40 suites with private bath could accommodate 150 guests. It was operated for several years by Canadian Benjamin Dickinson, who would leave in 1904 to run his own business, the Dickinson Hotel, pictured below. The hotel was deliberately burned down in 1914 by Walter Everton acting for the owners who were hoping to claim on their insurance. The Club House survived and is now a home on Fairview Avenue.

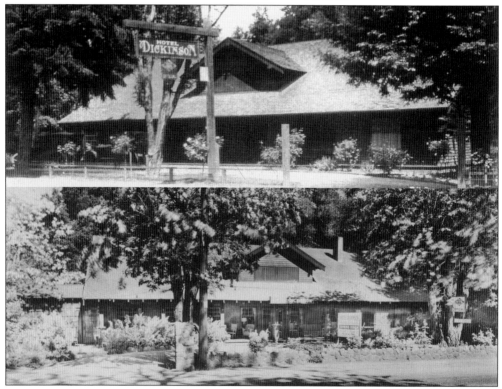

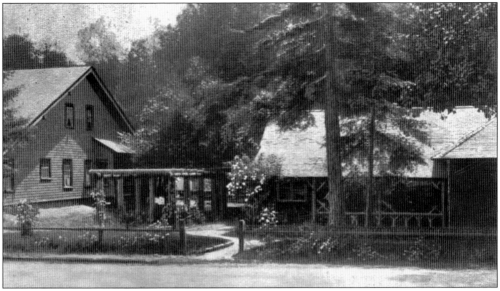

This image of Hotel Dickinson in Ben Lomond shows the pergola and one of the cottages. The former hotel still stands just south of the bridge over the San Lorenzo River on the east side of Highway 9. After Dickinson's death, the establishment, renamed the Town and Country Lodge, was run by Gordon Perry. (Courtesy of the Ronnie Trubek Collection.)

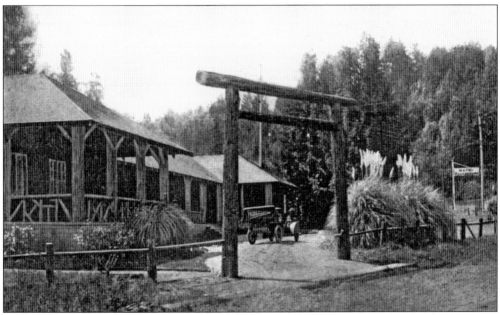

On Highway 9 just to the south of the lower bridge in Ben Lomond stands a disused fountain. The fountain is the last vestige of what was once the entrance to Hotel Rowardennan, pictured here. The rustic hotel and cottages were a favorite vacationing resort for guests from San Jose, Oakland, and San Francisco. The hotel was constructed on 300 acres by Thomas Bell. Its facilities included bridle paths, tennis courts, a dance floor, a bowling alley, boating, and swimming. It was later known as the Ben Lomond Lodge.

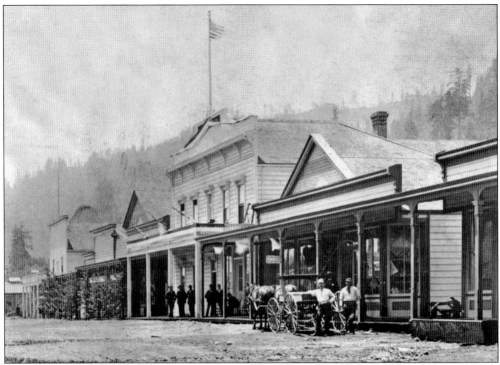

Pictured here is the main street of Boulder Creek looking south. The grand building towards the center—a hotel—was known as the Alpine House. It was on the corner of what is now Highway 236 and Central Avenue.

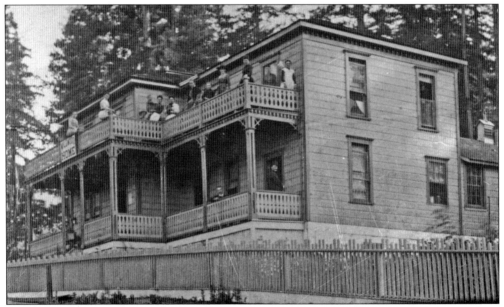

In 1905, Julia A. Glenn purchased the 1886 Wildwood Home resort in Boulder Creek. It was in a dilapidated state. Glenn refurbished the hotel and grounds "until one would hardly know the old place" to the delight of the local townspeople. It stood at the corner of Lomond and Pine Streets.

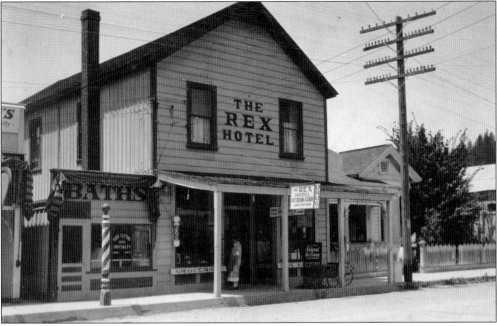

This building, pictured as the Rex Hotel, is described on a 1908 Sandborn map as a boarding house, and was the site of the old post office. In 1903, Mrs. Hatvick Tschurr opened the Occidental Restaurant in the building. It is often mistaken for the Basham House, which was located a couple of lots to the north. The Baldwin Lodging House, also known as the Basham House, is pictured in the center of the image below. It changed hands in 1902 from Rachel Baldwin to Lizzie Bickmore. In 1905, just after it was purchased by William F. Pierce, a new veranda was installed, and in 1911 it was remodeled. In the photograph, the sign hanging above the door of the building reads "Furnished Rooms."

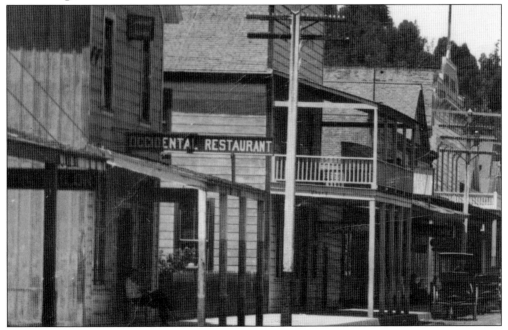

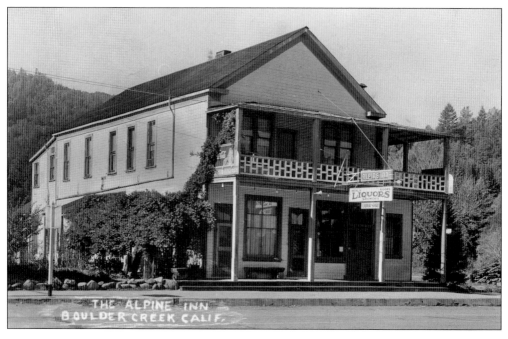

Built in 1897 by Henry L. Middleton as the Commercial Hotel, this hotel, pictured above, has had several names, including the Alpine Inn. In 1897, it was leased to George Dennison, who operated the hotel. His brother Andrew leased the nearby Boulder Creek House. The hotel was renovated in 1908 and renamed Big Basin Hotel in 1914, pictured below. It was torn down in the 1950s by Johnnie Montanari to make way for Johnnie's Super.

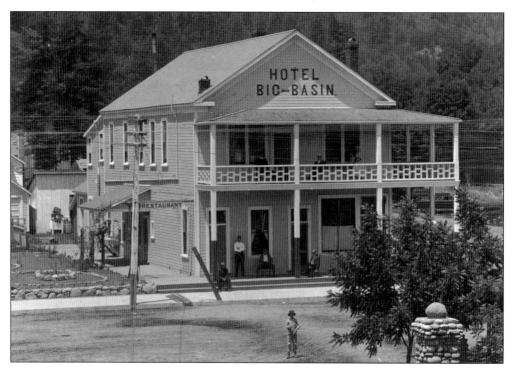

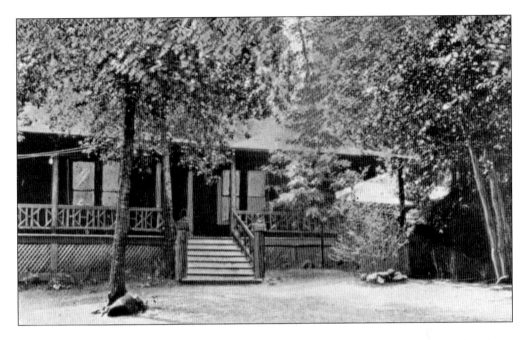

In 1905, the Minnehaha Hotel changed its name to the Bookdale Hotel. In 1915, the hotel was advertising its virtues of pure mountain air and water, no fogs or winds, excellent table and rates of just $2.50 per day and $12 per week with special rates for families. In 1923, Dr. D.K. Camp of Santa Barbara built Brookdale Lodge on the site. He tried to sue the owners of the Brookdale Inn, located just across the street, to stop them from using the name. The rustic log cabin lobby to the lodge, with rocking chairs on the porch and advertising the sale of National Ice Cream, is pictured below. The lobby, which still stands on the grounds of the lodge facing Highway 9 at the corner of Clear Creek Road, boasts an enormous stone fireplace.

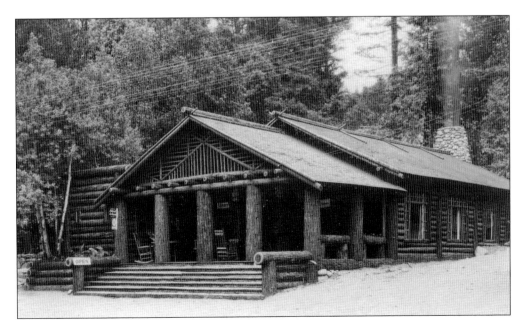

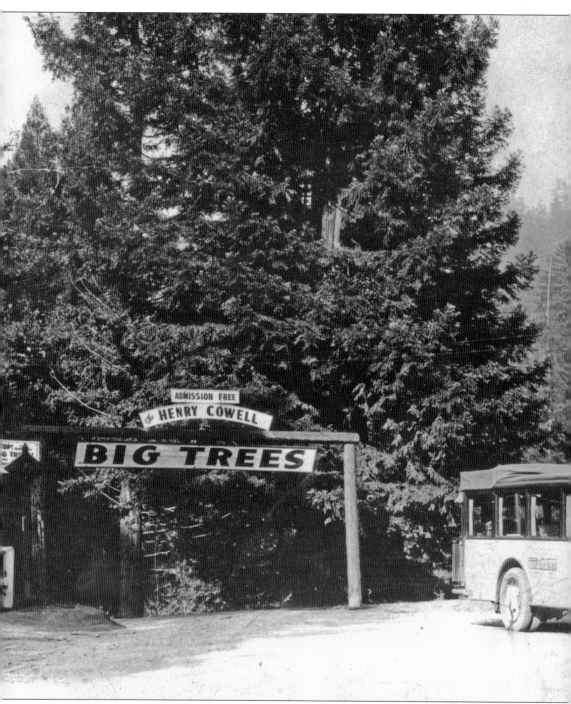

The Toll House resort is located next to Henry Cowell Park south of Felton. A toll house was constructed here in 1867 by George Collins. He had built the road south from Felton in order to transport lumber from the area to the mill in Felton. By the 1900s, the Toll House resort had 17 cabins, each reputed to have its own call girl. During Prohibition, the resort managers were fined

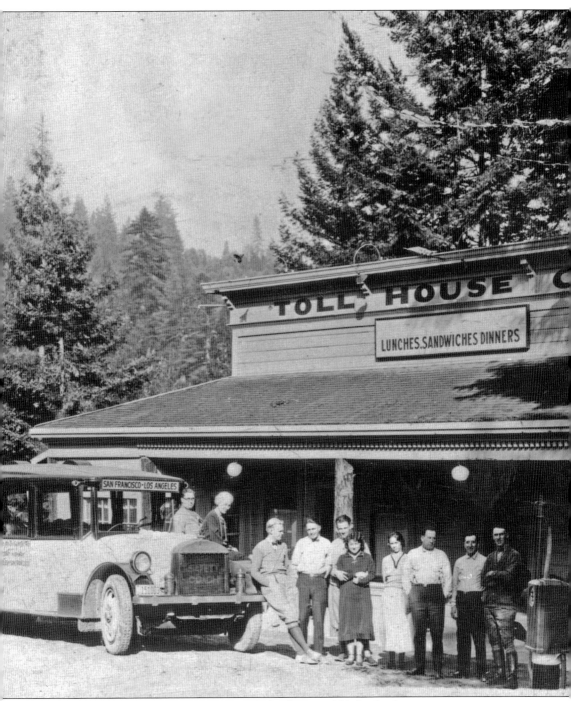

for serving liquor without a license. In 1915, the fine was $50. In this later picture, tourists on a California Parlor Car Tours bus stop at the entrance to the Big Trees Park. At this time, admission to the park was free. The Toll House was being operated as a café serving lunch and dinner.

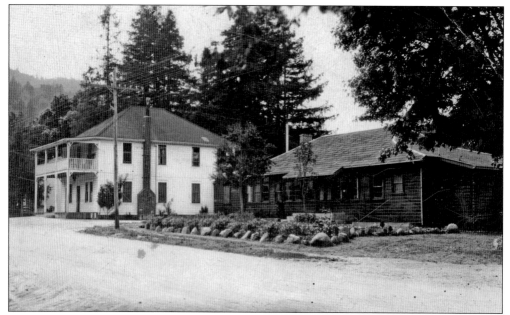

In 1916, Joseph Locatelli's newly constructed hotel, the Italia Hotel, opened on Big Basin way. Primarily used as a boarding house for men working in the logging industry, the hotel soon became popular with movie stars and crew who were filming at the nearby Poverty Flat film set. In the mid-1920s the redwood dining room was constructed, and the hotel was renamed Locatelli's Inn. It was sold to the Scopazzi family in the 1950s.

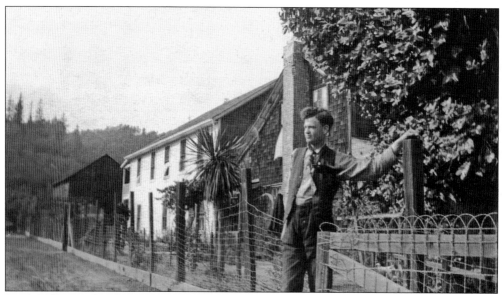

Ercole Villa was a hotel on Bear Creek Road just after Hopkins Gulch Road heading east. Giovanni "John" Ercole had purchased the former Michener farm property in 1913. Boulder Creek was dry, but there were several speakeasies, or "blind pigs." In 1916, both John Ercole and Giuseppe "Joseph" Locatelli were charged, Ercole because at that time he had no license, and Locatelli because he served alcohol without serving a meal.

Five

THE GREAT OUTDOORS

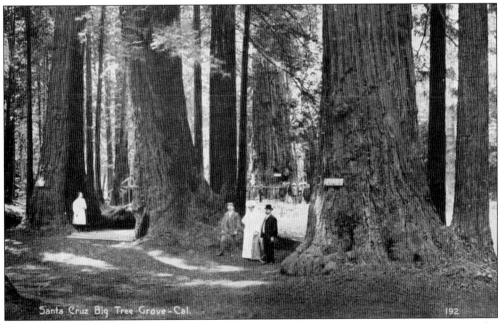

Santa Cruz Big Tree Grove-Cal. 192

In 1867, Joseph Welch bought a portion of the Zayante Ranch from Edward Stanly to save the redwoods from being logged. Known later as Welch's Big Trees Resort, it was destined to become a popular tourist attraction. Around 1900, photographer Andrew P. Hill visited the Big Trees Grove to take photographs. It is told that one of Welch's sons confronted Hill and insisted that he pay for taking commercial pictures of these redwoods, as the family had worked hard to build this popular resort. Hill refused, and it was perhaps this event that triggered Hill to campaign to save the redwoods for the general public. The next time he visited the area, Hill avoided Welch's Big Tree Grove.

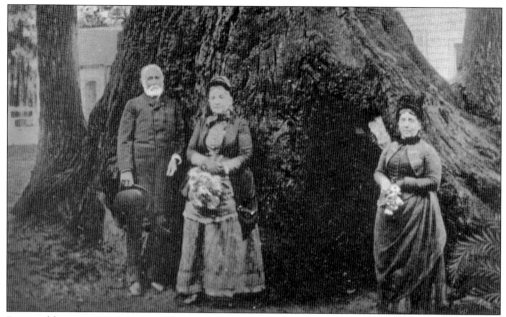

Pictured here in 1888, John C. Frémont and his wife and daughter stand in front of the tree in which in 1845 he is reputed to have spent the night. It was also home for Jacob R. Snyder, who in 1845, dressed in a buckskin suit, hunted deer for "four bits a hide." Before the Mexican War, the natives tried to prevent immigration. Jacob had journeyed west from Philadelphia, and the big trees and rugged terrain proved ideal hiding grounds for migrants such as he.

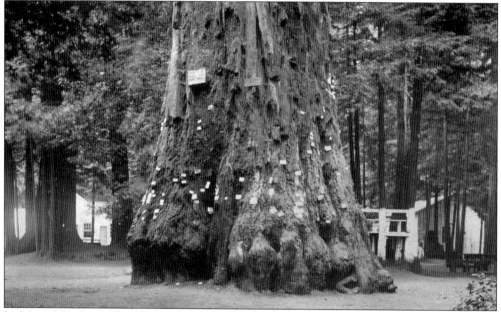

In May 1903, Pres. Theodore Roosevelt visited the Big Tree Grove. The president strongly disapproved of the practice of people pinning their business and personal cards to one of the redwood trees, pictured above. He gave a lecture on the "evils of vandalism" and the cards were promptly removed. He also requested that the sign for a tree dedicated in his honor earlier in the year be not larger than three-quarters of an inch by an inch and a half.

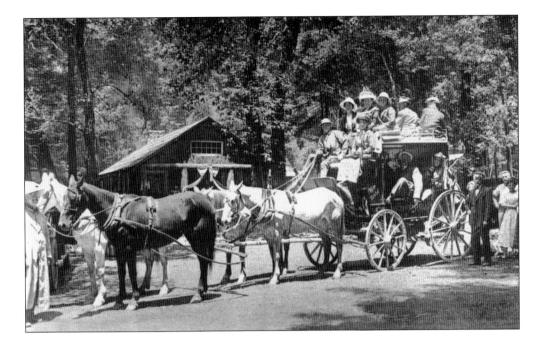

Visitors to the newly established California Redwood Park at Big Basin would ride the stage from Boulder Creek. Pictured above is the Moody and Cress stage. The Moody and Cress livery stables still stand on the east side of Central Avenue. George D. Cress is the driver of this stage, and two of the horses are Babe and Bess. Pictured below is the Elsom Stage. William Marshall Elsom owned stables in Ben Lomond and also ran a stage service to Big Basin. One of the first stage routes through Big Basin opened in 1886. It was operated by the South Pacific Coast Railroad between Boulder Creek and Pescadero. One of the later stage lines opened in 1917 between Saratoga and the park. It ran on Wednesday, Saturday, and Sunday from Morrell's candy store at 9:00 a.m., with the return journey leaving Big Basin at 4:00 p.m.

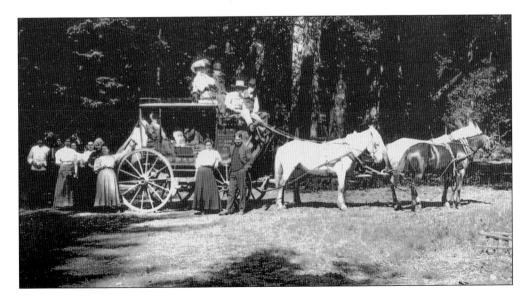

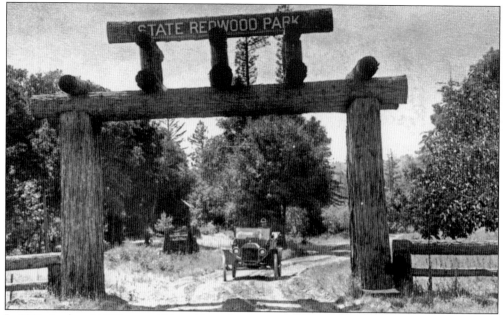

In 1901, Andrew P. Hill was widely publicized as being the discoverer of Big Basin; however, it was largely the efforts of former lieutenant governor William Thomas Jeter, who though elderly and confined to a hospital bed, wrote letters and made phone calls to promote the establishment of the park. In addition, efforts to preserve the old-growth trees were also promoted locally. Henry L. Middleton played a significant role. Middleton owned the road to Big Basin and much of the Big Basin land. In 1900, the Sempervirens club was formed. Through the efforts of its membership, which included many locals, the first state park—the California Redwood Park—was established in 1902. The state legislature had agreed to purchase the land from Middleton. In 1903, Middleton was appointed the temporary guardian of the park. In 1907, he donated an additional five acres for the warden lodge. When the park first opened to the public in 1903, there was only one road that terminated at the "old Sempervirens' club camp." It was proposed that a road be built to Governor's Camp, on Waddell Creek.

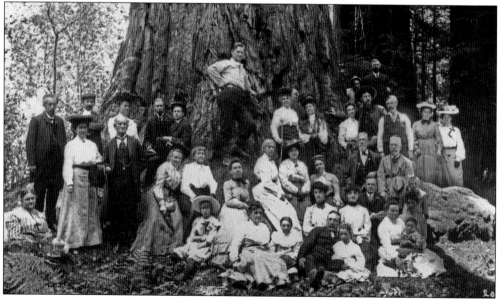

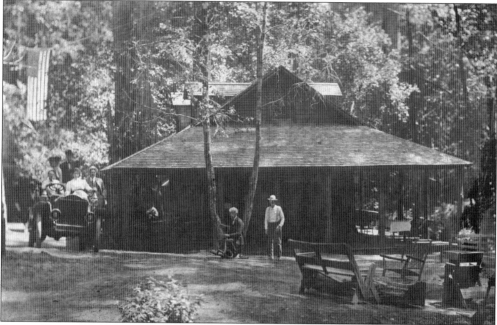

Pictured here is the Redwood Inn at Governor's Camp, Big Basin. In its early days, Mary "Abbie" Elsom, wife of stage service owner William Elsom, ran the state park inn during the summer months. Mollie Booth, wife of local contractor William Booth, also ran the inn. In 1913, the rates were $2 per day or 50¢ per meal, and camping was free for all.

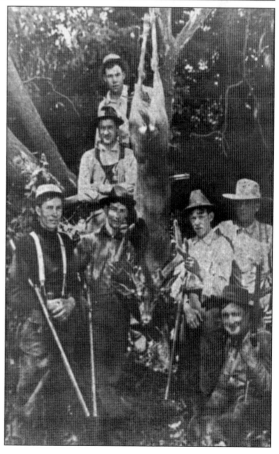

Hunting game was not just a pastime; for some it was a livelihood. Pictured here after a successful hunt are Jim Maddocks, Emmit Maddocks, Art VanDuesen, Frank Humphrey, Red Winkleblech, Charlie Newman, and Clene Maddocks. Hunting parties from San Jose, Oakland, and San Francisco would enjoy the regulated hunting season with fines being incurred by tourists who did not obey the rules. In 1907, it was reported that a record number of licenses had been issued.

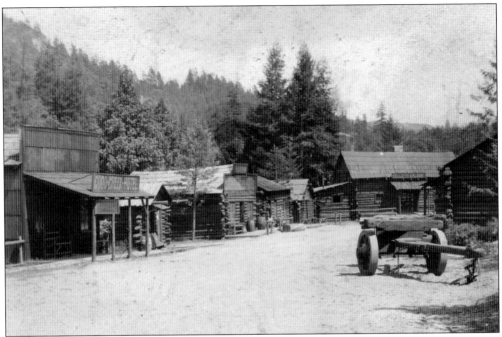

George E. Middleton, nephew of Henry L. Middleton, was the manager of the California Picture Company. He decided to film the silent movie *The Lily of Poverty Flat* in the Valley. He constructed a complete town of Poverty Flat for the movie set just west of Boulder Creek on the road to Big Basin. The movie was released in 1915 and starred Beatriz Michelena.

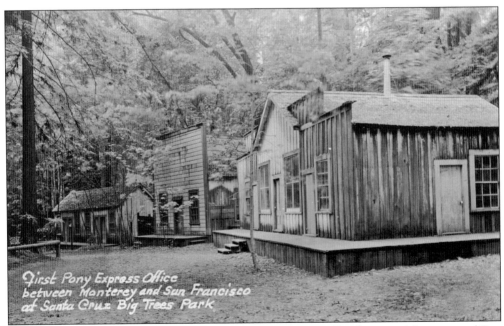

Even though this image is identified as the first pony express office between Monterey and San Francisco, the buildings, located at the Big Trees Grove, are believed to be part of an early silent movie set.

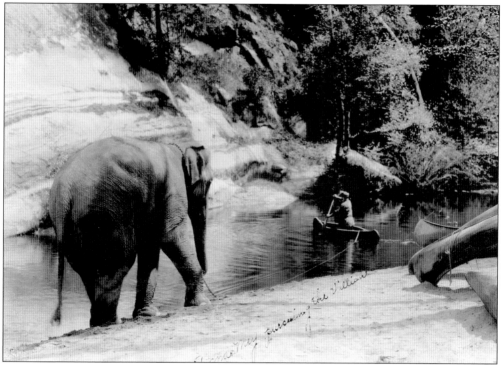

This photograph was taken during the shooting of the silent movie *Soul of the Beast* in 1922. Madge Bellamy was the heroine and Noah Berry the villain. In this scene towards the end of the movie, the villain is trying to escape. The location is Junction Park in Boulder Creek. Annie Mae, the elephant, foils the villain as he climbs the rocks to escape by squirting him with water.

In 1921, this cast and crew were photographed having fun during a picnic at the gorge on Longley's Ranch. The caption on the photograph reads "Best Bunch on Earth."

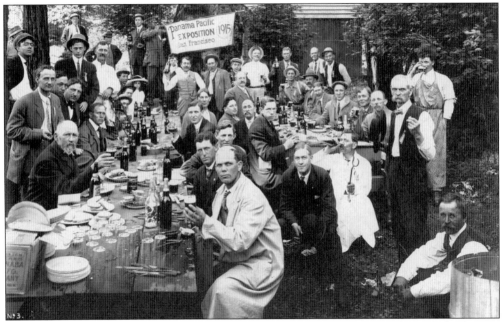

In 1915, in celebration of the Panama Pacific Exposition in San Francisco, Fred Moody (at front in white coat), Billy and Sam Beal, and Douglas and Ed Hoffman held a party in the redwoods. The guests appear to be in their Sunday best and many can be seen wearing a ribbon bearing the word "reception." During the exposition such a party was held at Big Basin for the American Society of Civil Engineers. The men journeyed from Santa Cruz by automobile, and since Moody and Cress Livery had taken delivery of a vehicle in 1913, it is likely that they provided transportation.

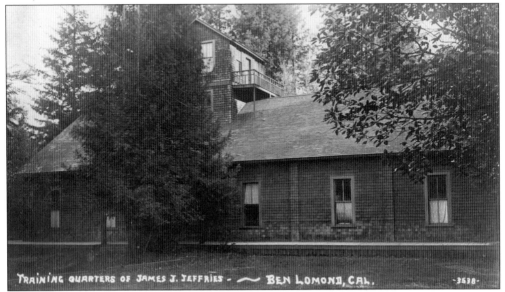

In 1910, heavyweight fighter "Big Jim" Jeffries moved his training camp to the Rowardennan Hotel in Ben Lomond. The undefeated Jeffries was lured out of retirement to fight Jack Johnson. Jeffries trained hard, starting his morning with a 10- or 12-mile hike "road trip." Other fighting celebrities would spar with him at the Rowardennan, such as world wrestling champion Frank Gotch and the legendary heavyweight boxer "Gentleman Jim" Corbett.

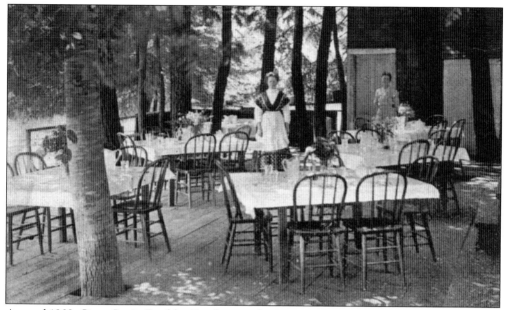

Around 1902, Camp Joy in Boulder Creek opened as a summer camp for boys. At the time, it was the only permanently established resort exclusively for boys in the west. It was established and managed by G. Ellingwood Joy, with a team of instructors and councilors, a matron, physician, a culinary chef, and a national park guide. The camp had a large library and reading room, and a workshop. Their motto was "Education Through Play," and boys were encouraged to bring their bicycles and even a horse, if they had one. Athletic activities included baseball, swimming, diving, rowing, croquet, canoeing, tennis, and boxing. Photography and drama were also offered, and the camp even had its own museum. Pictured above is the dining room where food was prepared by one of the "finest professional chefs to be found in the state." Below is one of the most victorious baseball teams at the camp, the Camp Joy Stars.

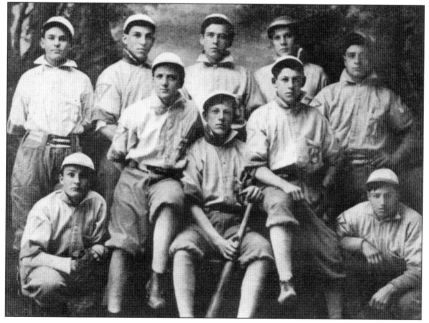

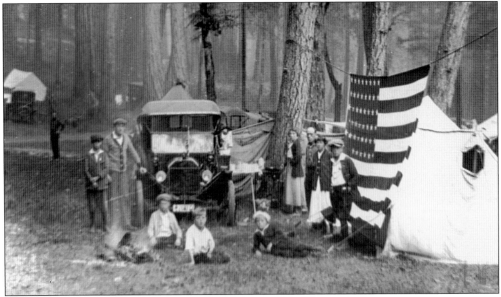

Auto camps, such as the one shown here, became very popular. In the 1920s, the Felton Grove Auto Camp advertised tents, cottages, and tennis courts. In 1926, the unpaved section of road between Camp Evers and Felton Grove was paved. The completion of the new road, now Mount Herman road, was hailed as "now permitting all-season touring into the Big Basin section."

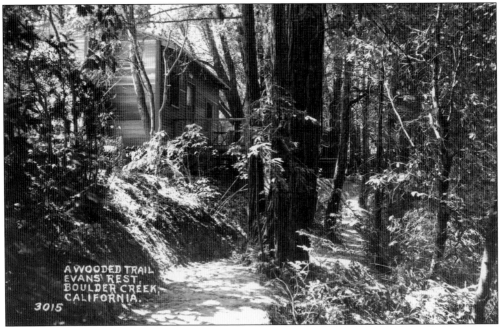

This is Evan's Rest, one of two park-like settings on the banks of Boulder Creek, at the north end of town. The other was Linden Park. George Linden, one of several aliases, had come to Boulder Creek in his later years after his life had been ruined due to drink. He worked for the railroad and requested that he be allowed to cultivate a worthless piece of land between the railroad and Boulder Creek. He created Linden Park, and it was enjoyed by the community and by campers. When Linden passed away, his funeral, held in the park, was crowded with local residents.

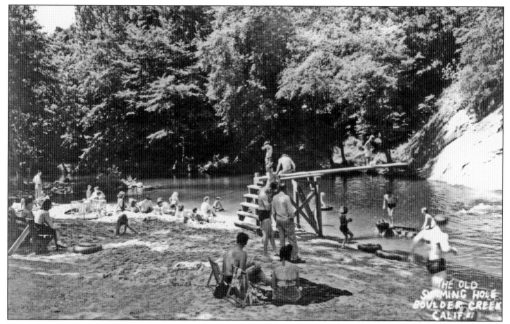

Now known as Junction Park, the confluence of Boulder Creek, Bear Creek, and the San Lorenzo River has long provided a favorite place to swim in the summer months. The junction of the creeks and river has also been called "the turkey-foot," a name that is thought to have been given to it by the native Ohlone people, because of its resemblance to a turkey's foot when viewed from the rocks above. In the early 1900s the river was dammed, and the Boulder Creek Improvement Society members, along with firefighters, hauled in sand to create a beach.

The San Lorenzo River was dammed in several places, creating swimming holes and boating lakes such as at Brookdale and Ben Lomond, pictured above.

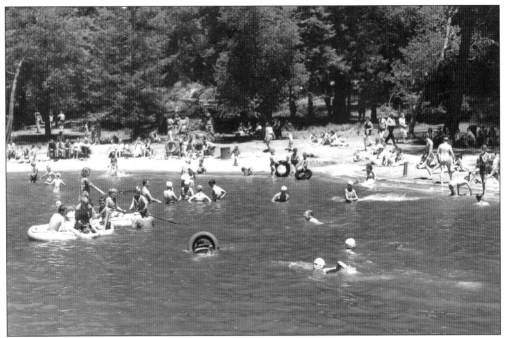

Today, Big Basin State Park is maintained as a natural setting, but in the early 1900s, artificial features such as the swimming pool pictured here were created for tourists. In addition to the office, cabins, general store, and restaurant, there were also tennis courts, a dance floor, a gas station, and even a barbershop.

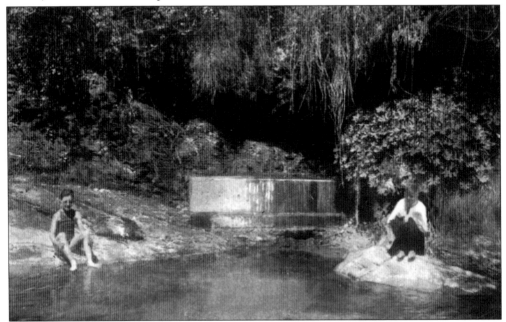

These boys are swimming in the white sulfur springs at Mount Hermon. With present-day water consumption much higher than in the past, many of these unusual types of water features have long since disappeared. There were once hot springs on Two Bar Road, and artesian wells flowed freely in the Valley. (Courtesy of the Ronnie Trubek Collection.)

Six

FROM CABINS TO HOMES

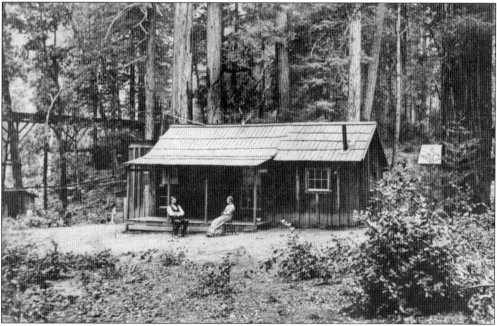

Pictured here around 1875 are Oscar Harmon, lumberman and mill owner, and his wife, Wilhelmina, sitting in front of their first home above Boulder Creek. In the background, the San Lorenzo Valley Flume can be seen.

Winfield Scott Crediford's house is often referred to as the "One Hundred Year Old House." It stands on Highway 9, on the northeast corner of South Street. It was Crediford who sold his land in the fledgling town of Boulder Creek to the railroad, and it was the railroad that laid out the town of Boulder Creek, as it is now known. The land was originally John Henry Alcorn's timber claim.

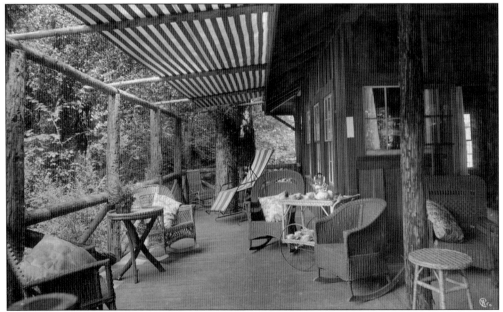

This is the porch of a cabin in Bonnie Brier Park on Bear Creek around 1907. The park, considered a desirable summer home location, was located just a 10-minute walk from Boulder Creek. It had nearly a mile of the creek running through it, "the banks of which are covered with lovely variety of ferns and flowers." In 1905, it was reported that the park was fenced, spring water was piped to each lot, and driveways had been laid out.

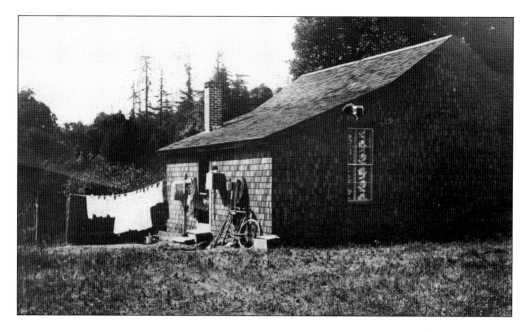

The above 1904 photograph is of the Herman Irwin home in Brookdale. It was formerly the cook house for the mill. Below is the home after extensions were built on to the house by Herman, his father, and his sister-in-law. The Irwins also had a chicken ranch. Herman's sister-in-law, Hallie Hyde, was married to William Irwin, a nationally renowned newswriter. Rather than be with her husband, Hallie preferred the serenity of Herman's Brookdale home. Hallie and William divorced in 1908, and she later married Herman.

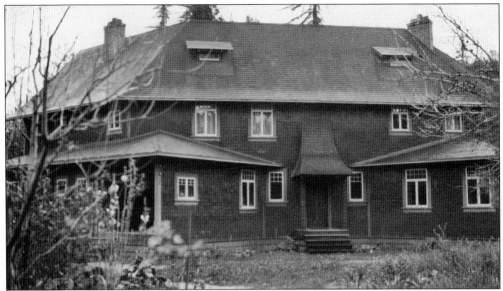

This is the Brookdale home of Herman and Hallie Hyde Irwin. Hallie designed the home, and it was built over a period of 10 years by Herman, Hallie, and David Irwin (until his death). The timbers, flooring, and doors were from the 1915 Panama Pacific Exposition in San Francisco and were shipped to Brookdale via the Southern Pacific train lines. The home, named Rivercroft, was completed in 1926.

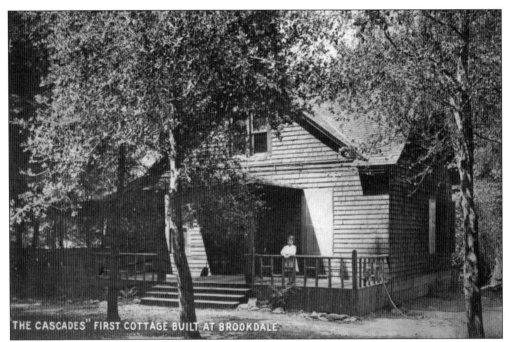

This is the first summer cottage to be built on the Clear Creek property that Judge John Logan had subdivided into lots. In the early 1900s, many wealthy families built summer homes here. It was a popular spot for Oakland families trying to avoid the East Bay summer heat. In 1904, Duncan McPherson, editor of the *Santa Cruz Sentinel* newspaper, purchased a lot to build a home.

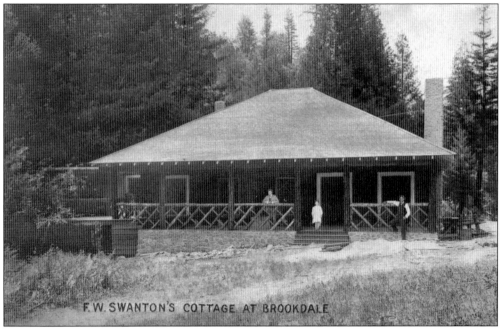

F. W. SWANTON'S COTTAGE AT BROOKDALE

Santa Cruz Businessman Fred W. Swanton built a cottage in Brookdale. Among his many business ventures, Swanton and his father built and ran the Swanton House Hotel in Santa Cruz in 1883. In 1889, with Dr. H.H. Clark, he started an electric light company, and was "one of the first to agitate the Santa Cruz Electric Railway project." Swanton would become mayor of Santa Cruz in 1927.

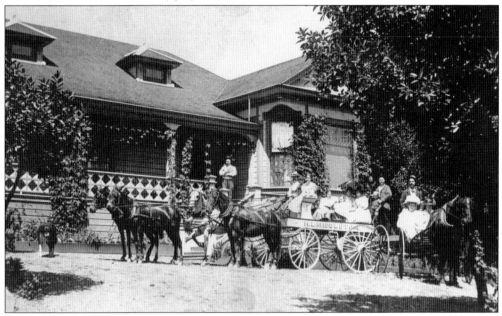

Known as Madrone Villa, this was the elegant home of Henry L. Middleton. The 10-room villa on Bear Creek boasted beautiful landscaping, a gazebo, and a greenhouse. It was the first home in Boulder Creek to have electric lights, which were installed in 1896 at the same time as his mercantile store was illuminated. Photographs of the villa featured prominently in a 1902 *Overland Monthly* publication.

FOREST PARK RESORT

This new and popular community for progressive people, although but recently established, is attracting many desirable settlers from every part of the United States and Canada. A beautiful tract of ground has been surveyed and platted into large lots and placed upon the market at reasonable prices. Already many neat cottages have been erected and others are projected.

Address The Forest Park Company,
Boulder Creek, California

J. C. McABEE GEO. I GOSLAW

California Redwood Park Stage Line

The Governor's Camp in the California Redwood Park, located in the heart of thirty-eight hundred acres of virgin Redwood forest—eleven miles of scenic ride from Boulder Creek. The quickest route, the most convenient accommodation and the best rates from all points Correspondence solicited

Special Round-Trip Rates from San Francisco and other points. Also to parties over fifteen in number.

Tourists can make round-trip from Santa Cruz to the Park in one day.

THE McABEE LIVERY STABLES

Phone, Main 215 *Boulder Creek*

To encourage people to move to the area, Ben Lomond, Boulder Creek, and Brookdale all produced booklets touting the virtues of their location. Boulder Creek described itself as "the Gateway to the California Redwood Park." The 1908 booklet promised a true and accurate description of one of the most favorably located communities in the state of California. Schools, churches, homes, and surrounding areas were described and local businesses advertised.

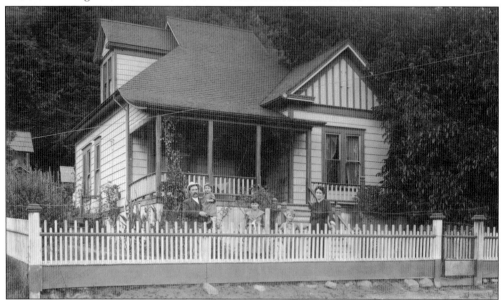

This is the Isaiah Hartman home on Boulder Street in Boulder Creek around 1906. This home was one featured in the booklet above. Isaiah, Maude, and their three children are standing in the front yard. Isaiah had come to Santa Cruz with his mother and six brothers in the late 1870s. He was a well respected businessman, real estate investor, and active member of the community. Isaiah was appointed justice of the peace in 1896.

Beautiful Ben Lomond

THE great State of California is so well known to tourists and seekers after health and recreation, that we need not, in this little souvenir, endeavor to say aught to add to its fame.

To the easterner, sweltering in the prostrating, humid atmosphere of the hot days and still more oppressive nights of an eastern summer, or freezing amidst the sleet, snow and ice of an eastern winter, the existence of a land in which oppressive heat in summer and chilling cold in winter are unknown, seems almost incredible. Yet such a land is California, especially that portion of it contained in the valley of the San Lorenzo, and in the vicinity of the beautiful little Santa Cruz Mountain town of Ben Lomond.

The country about Ben Lomond is a little world of exquisite beauty, made up of hills and dales, mountains and canyons, crystal springs, babbling brooks, and the beautiful San Lorenzo River flowing through the town. Leading in every direction from the town are cool shady walks and lovely driveways, inviting the visitor to beautiful groves or magnificent forests. Or, if one feels disposed to drive farther, Santa Cruz and the sea are but a short nine miles drive to the south, and the Big Basin with its immense forest of great Sequoias about an equal distance to the north. Or if one prefers to see the giants of the forests nearer by, then he can visit the famous Big Trees but four miles away. One can breakfast in Ben Lomond, visit

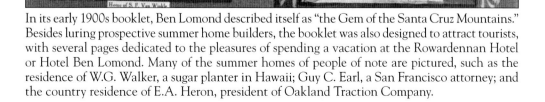

In its early 1900s booklet, Ben Lomond described itself as "the Gem of the Santa Cruz Mountains." Besides luring prospective summer home builders, the booklet was also designed to attract tourists, with several pages dedicated to the pleasures of spending a vacation at the Rowardennan Hotel or Hotel Ben Lomond. Many of the summer homes of people of note are pictured, such as the residence of W.G. Walker, a sugar planter in Hawaii; Guy C. Earl, a San Francisco attorney; and the country residence of E.A. Heron, president of Oakland Traction Company.

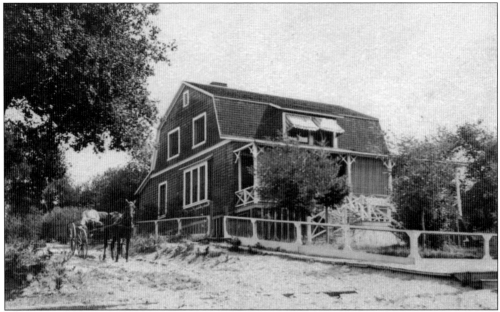

Pictured above is the Ben Lomond home of capitalist Bartholomew Philip Moore and his wife, Ann. The home, known as Sunnyside, is located on the corner of Pine Street and Glen Arbor Road. In 1908, Moore erected a building as a museum to house his collection of antiques, fine furniture, and curiosities, pictured below. His son and daughter-in-law—furniture designer Edward Moore and Mae Blackeney—also lived in Ben Lomond. The building was constructed of lumber from "the old Little Rest home." In March 1909, it was reported that he had begun to tear down and move his home; he died just a few days later.

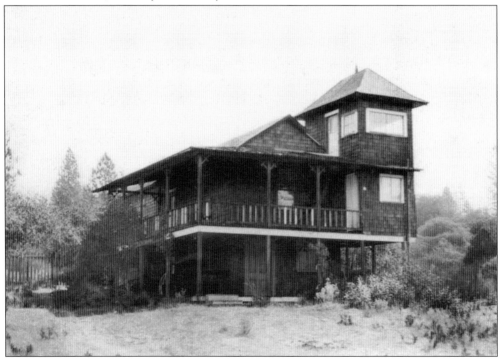

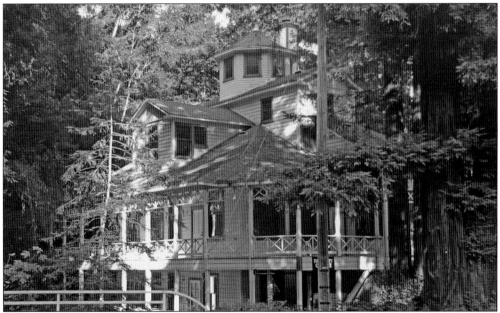

Built in 1904 by Milo Hopkins for Frederick A. Cody and his family across the railroad tracks from Cody's Ben Lomond Hotel, this magnificent octagonal house is quite unique. In the center of the building is a court, which is illuminated by skylights. Balconies wrap the exterior, and the interior appointments are handsome. The 12-room building was designed by Cody and is similar to the Partridge House in Flushing, Michigan, close to where Cody had spent his childhood.

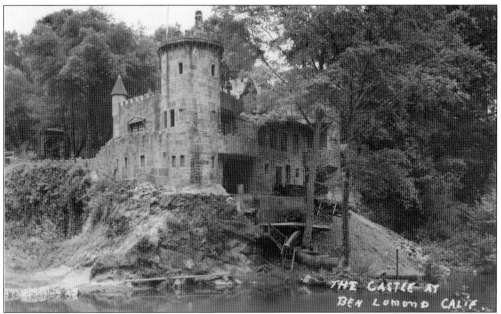

Robert Howden and his wife, Elizabeth, were Scottish nationals. They began building this home, modeled on the castles of their homeland, in the early 1920s on the banks of the San Lorenzo River in Ben Lomond. Robert, a stonemason and carver, owned a tile factory in Oakland. He used his skills to etch glass panes depicting Scottish scenes for the windows of his home. The castle was completed around 1927.

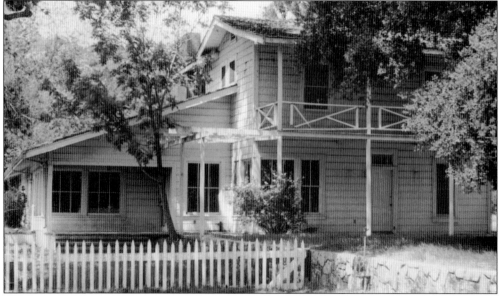

In 1866, Joseph and America Kenville homesteaded 44 acres on what is now Quail Hollow Ranch. Kenville added an additional 88 acres to the ranch in 1870. They grew all types of produce, but especially melons. They sold the property to William and Leona Richards in 1902. Richards was a nurseryman and planted both domestic and exotic fruit tees on the farm. The produce from the farm supplied the hotels in nearby Ben Lomond. In 1937, the owner of *Sunset Magazine*, Larry Lane, purchased the property and named the ranch Quail Hollow.

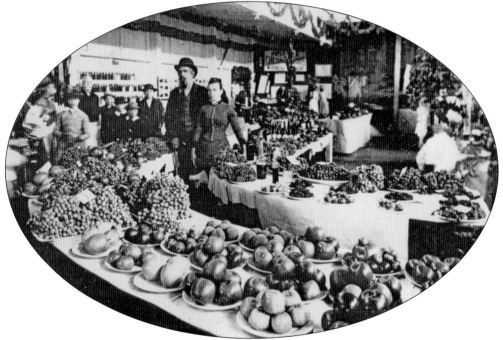

Christian Horstman and his future daughter-in-law are pictured at the Sacramento State Fair, around 1885, displaying fruit from Applethorpe Farm on Bear Creek. Fruit grown on the farm included apples, apricots, and grapes.

Seven

SUPPLYING THE DEMANDS

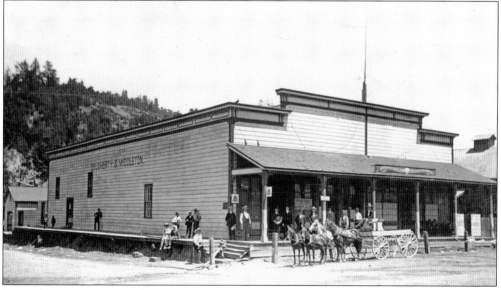

In 1885, James F. Cunningham erected a store in Boulder Creek opposite what is now Highway 236. In 1887, the Wells Fargo & Company's express office was moved from the depot to the store, and Henry L. Middleton was appointed agent. In partnership, Middleton and James Dougherty took ownership of the mercantile store until Dougherty sold out to Middleton in 1898. In 1896, it was the first building in Boulder Creek to have electric lighting installed, power being generated by water from the San Lorenzo River.

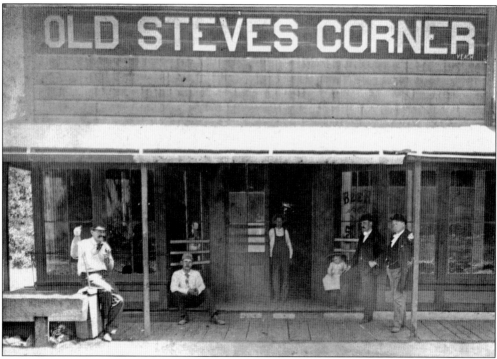

In the 1890s, one of many saloons in Boulder Creek, Old Steve's Corner, stood opposite the general store, which was on the southwest corner of West Park Avenue on Highway 9.

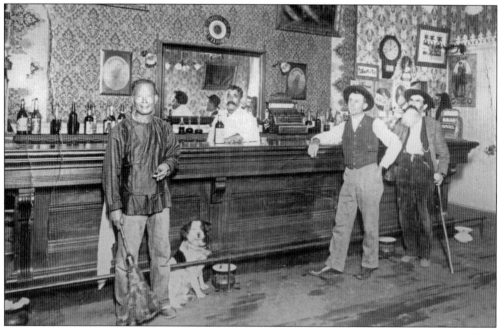

Pictured here is Sarmento's Bar on the east side of Central Avenue in Boulder Creek, c. 1900. Bar owner Manuel C. Sarmento stands behind the bar. The other men are, from left to right, Charlie Wing and his dog, Joseph Mello, and William Puncher. Sarmento rented the Kent Building next door for a meat market. In 1909, Mello bought the business from Sarmento.

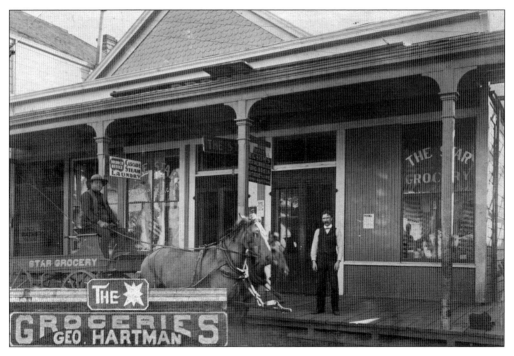

The photograph above of George Hartman in his grocery delivery truck was taken in 1904. He purchased the Star Market, a grocery and dry goods store located adjacent to the Alpine Hotel, in 1902. The store changed hands in 1905, and in 1906 it was enlarged. Hartman family members operated stores at several locations in Boulder Creek. The interior of one of the stores is pictured below. Note the brooms hanging from the ceiling light fixture.

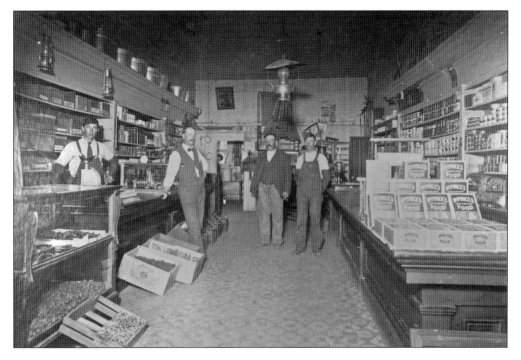

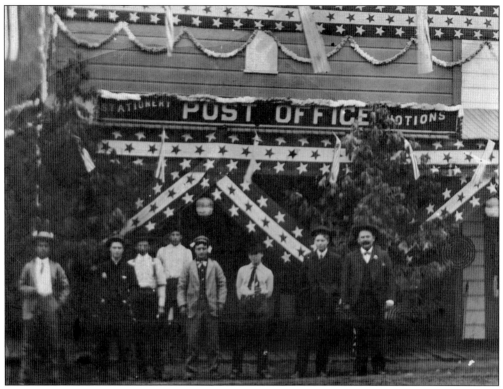

Next-door to the *Mountain Echo* newspaper offices (see opposite) was the Boulder Creek Post Office. In 1905, a fire in the roof and upper part of the post office was noticed by Alma Goerecke. She shouted "fire" to alert the occupants, and her son, Francis, ran across the street and rang the fire bell. Many willing hands came to help; within minutes, the hose cart was attached to the hydrant close by, and the building was saved.

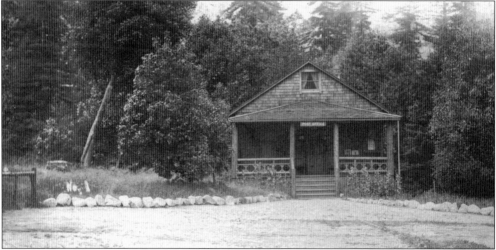

As the vacationing community at Brookdale grew in the early 1900s, amenities such as this post office were added. In 1904, the *Mountain Echo* newspaper reported that Brookdale was "crowded with tourists." The same year, a store building was constructed, and a year later, a dance pavilion was built.

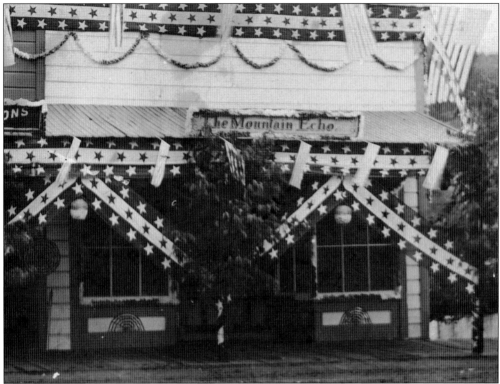

Next to the post office on the corner of Central Avenue and Forest Street in Boulder Creek were the offices of the *Mountain Echo* newspaper. The newspaper was founded in 1895 by Charles Campbell Rodgers. Winfred Scott Rodgers Sr., his brother, was also an editor of the paper and continued in that role after his brother's untimely death in 1898 at age 57. The newspaper was the successor to the *Boulder Blast*, and the first edition was October 24, 1896, describing itself as "the old paper under a new name and management." The editor of the *Blast* had been Rev. J.R. Watson, who was called to "other and urgent fields of usefulness." The *Mountain Echo* described its platform as "the advocacy of truth, justice and right as we see it."

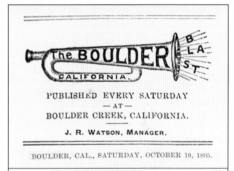

PUBLISHED EVERY SATURDAY
— AT —
BOULDER CREEK, CALIFORNIA.

J. R. WATSON, MANAGER.

BOULDER, CAL., SATURDAY, OCTOBER 19, 1895.

Huntington's Visit.

Boulder is seldom left out when noted men come this way and last Sunday the great C. P. made us a visit. Mr. Huntington was accompanied by a luminous train which nearly filled his private car, and fairly made the natives stare. The most prominent figures of the train, in sight, were H. E. Huntington, the great magnate's nephew, J. Krettschnitt, the new General Manager, J. H. Fillmore, the Gen. Supt., William Hood, Chief Engineer, J. L. Frazier, Supt. Coast Division, and C. W Baxter, Roadmaster. Collis sauntered over to a hotel and very kindly paid for a game for the boys.

In 1916, Luther E. McQuesten took over as publisher of the *Mountain Echo* newspaper. Owed money by his subscribers, faced with the high cost of printing, and a paper shortage, he printed four editions of the newspaper on cottonwood leaves, according to the *American Printer*. The front covers of two editions are shown here. In the subsequent edition, he printed the text of all four, for those who might have found the "fig leaf editions" difficult to read.

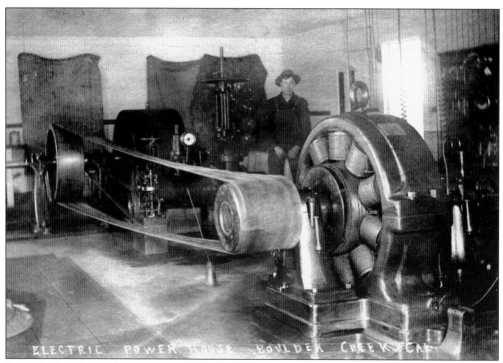

In 1902, the Elmer Electric Company, owned by Robert G. Elmer, erected a plant in Boulder Creek. Electricity from a water-powered generator illuminated the streets of Boulder Creek. A year later, Boulder Creek Electric Light and Water Company was formed, and Elmer's brother Charles assumed charge of the new powerhouse. It is uncertain which plant is pictured here.

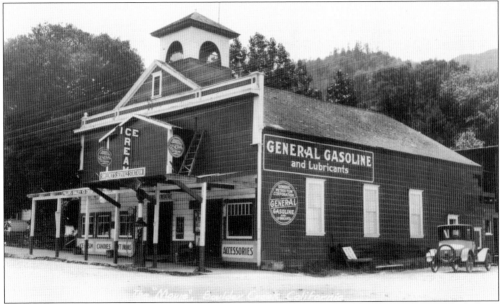

On July 15, 1891, a devastating fire swept through downtown Boulder Creek. The Dougherty and Middleton store was one of the few to escape the flames. In reaction, the men formed a volunteer fire department, the Boulder Creek Hose Company. Members raised $75 to purchase a secondhand hose cart from the Alert Hose Company. Funds were then raised to build a hall, and in 1894 the Boulder Creek Hose Company Building Association filed articles of incorporation with a capital stock of $5,000. The Fireman's Hall on the corner of Forest Street and Central Avenue was erected, and in 1897 they purchased a bell. Unfortunately, the bell did not work and had to be replaced. The replacement bell, pictured below, hangs outside the current fire department. The bell had been used at the California Jubilee Fair, in 1898, and had been rung (by an electric signal) by President McKinley in Washington to open the fair. The rebuilt hall, pictured above, was purchased in 1915 by Albert Sweeny, who also used it as a movie theater showing the latest silent films.

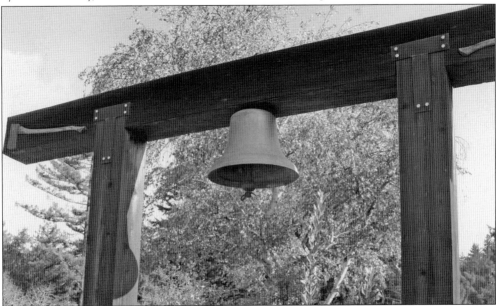

San José's Southern Lumber Company started business in the San Lorenzo Valley. Its lumber yard was close to the bridge in Boulder Creek adjacent to the Commercial Hotel. In the early 1900s, it ran logging and tan bark operations. The Boulder Creek company first opened its yard in San Jose in 1910.

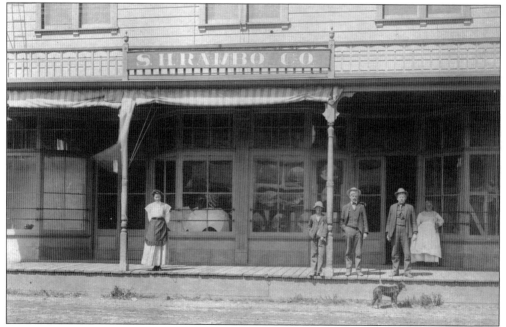

Samuel H. Rambo desired to move his merchandising business to a more central locality in Boulder Creek. In August 1900, he opened for business on the lower floor of the IOOF building, occupying the entire space with his merchandising business. Rambo's store was considered a credit to the town.

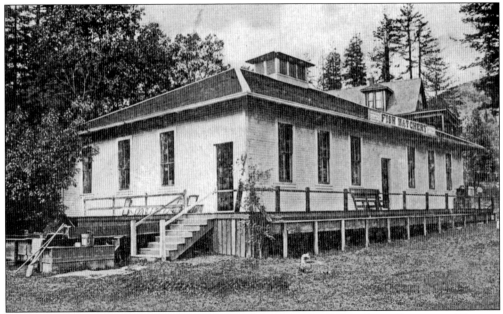

In 1905, the Brookdale fish hatchery opened. In the first year, it raised a million trout. The tiny fish had to be released into streams early that year, as the growing ponds had not yet been built. In 1910, the hatchery raised over two million steelhead trout. The eggs for the hatchery were obtained from the California Fish and Game Commission spawning station at Scotts Creek.

In 1884, telephone lines were extended, and Santa Cruz was connected to Felton. It took a while for the lines to be extended northward, but in 1900, a telephone was installed in the Boulder Creek depot. This building in Ben Lomond, formally the Fredda Carr photography studio, was once the Ben Lomond telephone exchange.

This photograph was taken by Johan Bjork, a Finnish logger. On the left is Andrew Dahl's wheelwright shop; the date is unknown. In the late 1890s, Dahl had a blacksmith shop in Lorenzo. He opened his Boulder Creek auto repair shop in 1910.

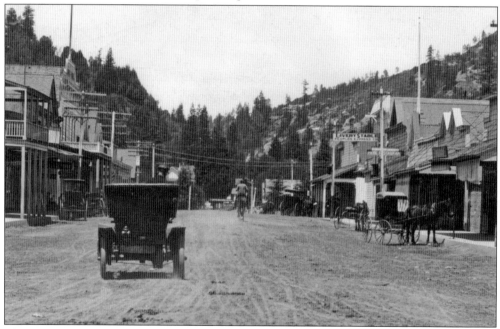

This c. 1910 picture of Boulder Creek's unpaved Central Avenue illustrates the transition in transportation, from horse and cart to horseless carriage, which would change life in the Valley dramatically over the subsequent years. In 1913, the Moody and Cress Livery Stables on the right acquired its first automobile, and the business was renamed Moody and Cress Auto Livery.

Eight

FROM ONE ROOM TO FOUR

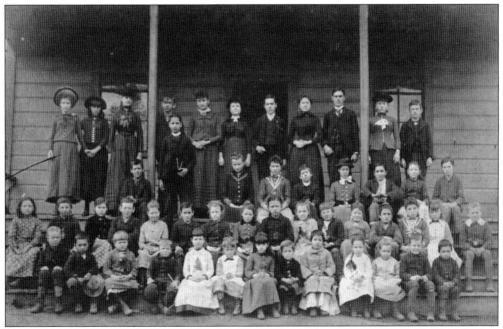

The first school in the San Lorenzo Valley was established in 1863, just south of Felton and called the San Lorenzo School. It was renamed Felton School in 1875. This photograph is dated 1888 and was probably taken on the steps of the hall on Bennett Street (now Felton Empire Road), opposite the Grand Central Hotel. In 1895, funds were secured to build a new school on Baldwin Avenue, now Highway 9, between Kirby and Hihn Streets.

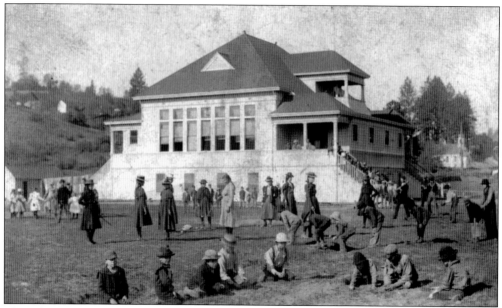

The Felton school and school library burned down in 1907, the cause thought to be a faulty flue. At the time, it was considered the finest building in Felton. The loss was estimated at $7,000. Classes were held in a hall while the new school building was constructed. This photograph is dated 1906 and shows the school before it burned down.

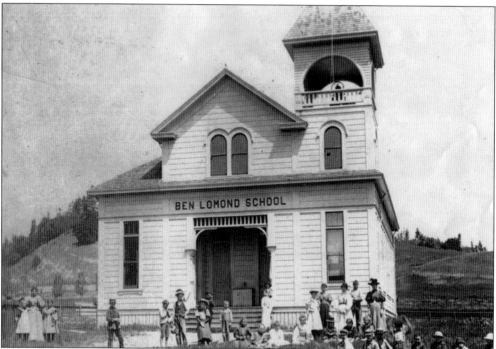

The first school in the Ben Lomond area was Newell Creek School, named for the creek by which it stood. It opened in 1876 and was renamed Ben Lomond School District in 1894. A new school, Ben Lomond School, was built within the growing settlement. It was located on Central Avenue and opened in 1895.

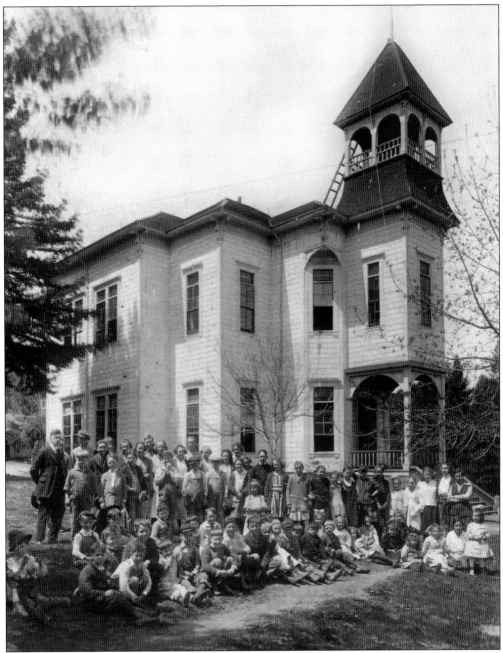

The exact location of the first school in Boulder Creek is uncertain, but most likely was on what is now West Park Avenue. The second was built on Debbie Lane. The school soon outgrew the structure, and graduating exercises had to be held at the nearby Washingtonian Hall. Land on a hillside overlooking the town was donated by the Felton Flume and Transportation Company. When this magnificent new four-room grammar school was built in 1891, the school on Debbie Lane was converted into a dwelling and Winfred Scott Rogers purchased the property.

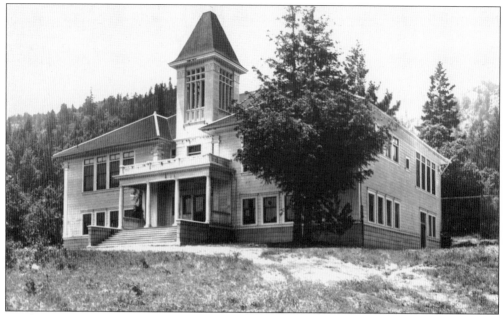

The Boulder Creek Union High School first opened in July 1905 in temporary quarters in the Tackitt building. The principal was Roy Dickerson and his assistant was Mamie Cooney. There were just 14 students in the ninth grade and seven in the 10th. Because the temporary quarters had no laboratory facilities, 11th and 12th grades could not be accommodated until the completion of the new high school building, pictured here, in 1906.

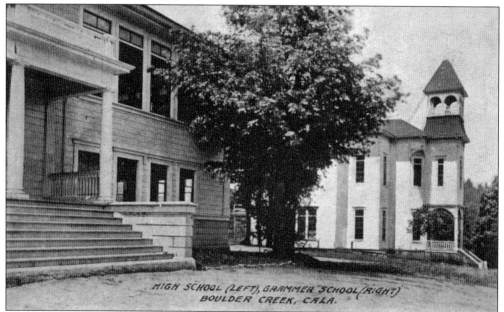

The high school, which served the school districts of Alba, Bear Creek, Ben Lomond, Boulder Creek, Dougherty and Sequoia, was completed in April 1906, just days before the earthquake. Granite Rock Company of Watsonville won the construction contract, which was for $7,845. The school suffered damage in the earthquake and had to be closed again while repairs were made. In the 1940s, the school was renamed San Lorenzo Valley High.

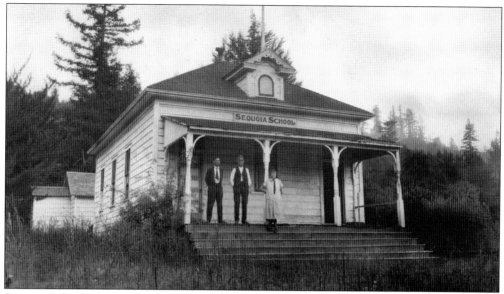

Sequoia School, close to Big Basin State Park, burned to the ground twice. The first school was located five miles from Boulder Creek towards Big Basin. It was lost to fire in 1893. The second, located at Missouri Flat on China Grade, was lost in a huge forest fire in 1904. The third, built in 1905, was also on China Grade, at the new road to Big Basin. It closed in 1924.

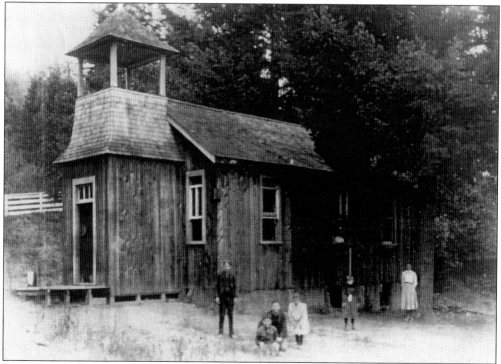

Alba School was built in 1895 for the children of the families that lived on Ben Lomond Mountain. The one-room schoolhouse on Alba Road is now a community center and library. When Sequoia School was closed in 1924, the building was dismantled, transported to Alba School, and reassembled on the back of the building, where it stands to this day.

This watercolor of the little one-room schoolhouse, Bear Creek School, was painted by Doris Levin, nee Pilger. It was established around 1886 and was closed in 1921. It was located close to Pilger Road, about four miles from Boulder Creek on Bear Creek Road. Another one-room schoolhouse, located about four miles north of Boulder Creek, was the Dougherty School. It was established in 1889 to accommodate the children of the Dougherty Mill lumbermen.

Brown School, which was located on Bear Creek Road close to the intersection with Skyline Boulevard, was established in 1875. It is likely named after Gustave Brown, a farmer with a large family who was granted land in the neighboring section in 1874. The school was closed around 1950.

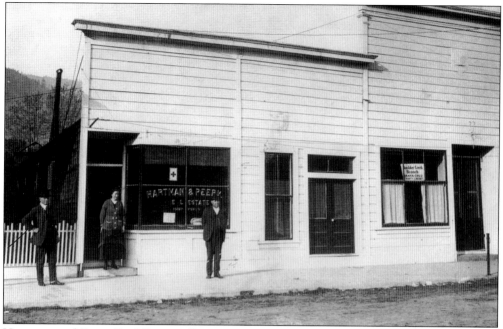

Hartman and Peery Real Estate office was located next to the Boulder Creek library. This photograph was taken in 1930. William B. Peery, who is also in the cover photograph, is on the left; secretary Miss Allison stands in the doorway; and Isaiah Hartman is on the right. The building stands on the northeast corner of Central Avenue and Lomond Street.

In December 1910, the Ben Lomond Improvement Society started organizing a library and park. They asked the owners of buildings on the south side of Mill Street if they would move their structures to the north side to make room for a park, and most agreed. H. Francis Anderson deeded his property for the library in exchange for lesser valued land on the north side and funds were raised from summer vacationers in San Francisco. In March of the following year, the library opened. It was officially dedicated in 1914. (Inset image courtesy of the Ronnie Trubek Collection.)

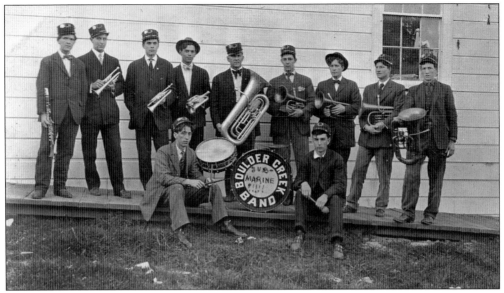

This is the Boulder Creek Band in 1909. Two members of the group are identified: Robert Waters seated on the right, and Art Waters standing fourth from the right. In 1908, the band played at the Sempervirens Club's Admission Day event at Big Basin Park. California Admission Day on September 9 commemorates California's admission into the union as the 31st state. It is a legal holiday in California and once was widely celebrated with parties and picnics.

Pictured here are 1904 graduates Winnie Rogers, Emma Hesse, Julius Lassen, Henry Aram, principal Professor Hart Benton Scott, Alice Rollins, Cody McDonald, Anna Fritch, Robert Easly, Willmott McKenzie, and Arthur Waters.

Nine

A SENSE OF BELONGING

The first fraternal organization in Boulder Creek was the Washingtonian Society. It met in the schoolhouse until funds could be raised to build a hall. The society was formed to promote temperance, improve literary knowledge, to generally qualify themselves for the varied duties of life, and to provide amusements, necessary to the "relaxation of mind or exercise of body." The hall was built in 1876 near the location of the library today. In 1898 a skating rink opened in the hall. It was razed in 1900.

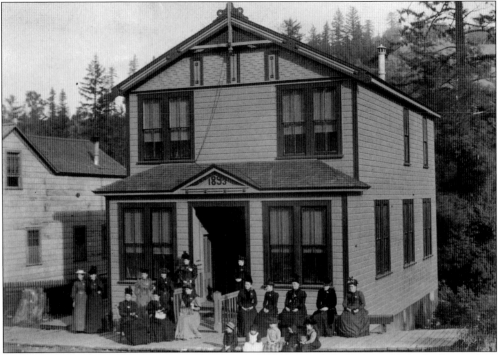

In 1893, the Women's Christian Temperance Union (WCTU) movement established a free reading room in Boulder Creek. Its goal was to provide the men with an alternative to the saloons and brothels in the town. The first floor of the building housed the library and the WCTU parlor; the second floor housed the librarian and their family. In order to raise funds to support the reading room, events such as a Martha Washington Supper (in honor of the first First Lady) and a Festival of Days were held in local halls.

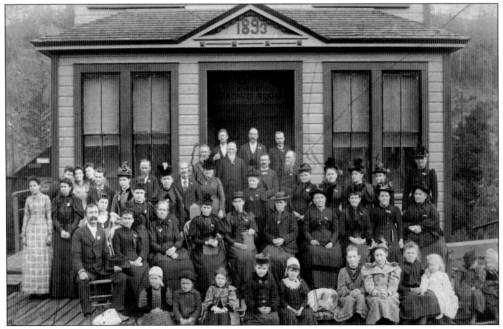

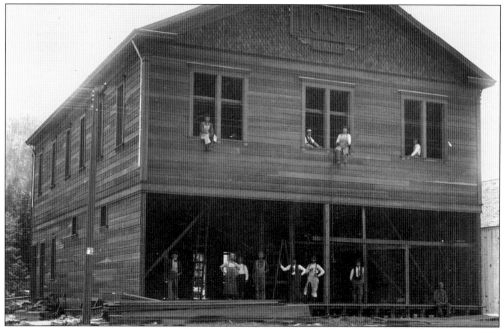

Boulder Creek Lodge, No. 152, of the Independent Order of Odd Fellows (IOOF), was instituted in February 1900 by district deputy grand master Charles E. Taylor of Watsonville, and grand secretary Shaw of San Francisco, with a team of instituting officers made up of members of Watsonville and Soquel lodges. At the institution, there were nine charter members, or former Odd Fellows, and 34 initiates, making 43 members in the lodge.

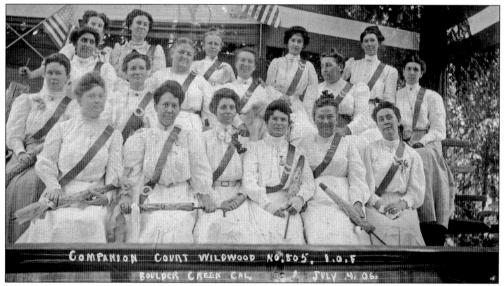

Pictured here are the ladies of Companion Court Wildwood in 1906. Court Wildwood No. 633 was the Boulder Creek subordinate court of the Independent Order of Foresters (IOF), which was instituted in September 1890. The IOF was a fraternal organization and just one of a number of "friendly societies." Initiation fees in 1904 were $5. Dues were based on the amount of sick and mortuary benefits held by the individual, but the monthly dues were just 85¢ for coverage of $1,000.

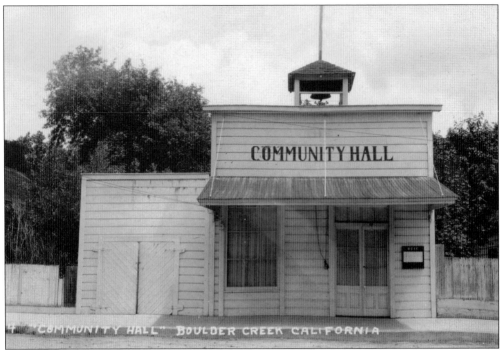

Originally the site of a bakery and a confectionery, around 1900, this became the Boulder Creek Community Hall. The building was given to the fire department, and the town's hand-pulled hose cart was housed in the garage at the side. The building is now Joe's Bar.

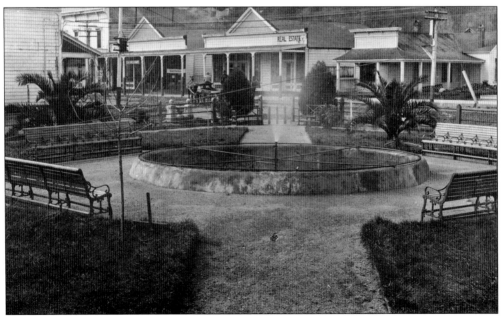

In the early 1900s, the Boulder Creek Improvement Society was very active. Members cleaned the town, urged owners to beautify their streets, planned street pavements, and built this little park on land donated by the railroad. The community plaza was located where the fire department is today.

The Presbyterian church in Felton was built in 1893 on the corner of Bennett Street (now Felton Empire Road) and Cooper Street (now Gushee Street) and was used by the congregation until 1955, when they moved to a larger facility. It was bought by Nick and Fay Belardi. It was intended that the building would be moved to another site, and the Beladis would build a home. Faye was tragically killed soon after in a car accident, and Nick gave the property in trust to the citizens of Felton. It became the Felton Branch Library. The building was placed on the National Register of Historic Places in 1978.

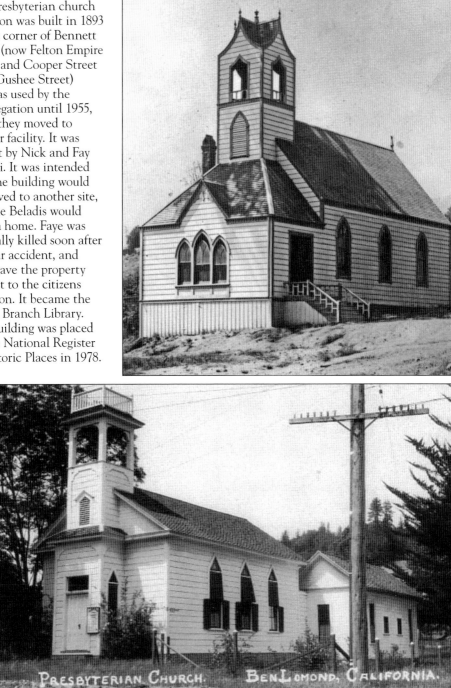

James Pierce, Pacific Mills president, donated land in Ben Lomond for a nondenominational community church in the late 1870s; however, since no services were being held in the church, he decided to sell the property. A Presbyterian, Alice Corbett, donated $400 for the purchase, and others contributed a similar amount. In 1891, the Presbyterian Church, affectionately known as "Wee Kirk" was dedicated and Rev. J.A. Mitchell became the first pastor.

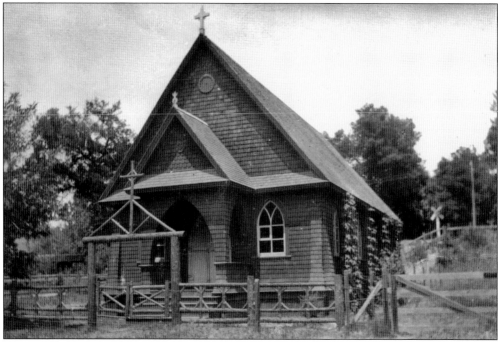

In 1899, the Episcopalians of Ben Lomond raised money to buy land and to build a church. During construction, services were held in Ben Lomond Hall. It is believed that the building was constructed by Milo Hopkins and was consecrated by Bishop William Ford Nichols in July 1901. It is named for the patron saint of Scotland. (Courtesy of the Ronnie Trubek Collection.)

Grace Mission was established in May 1905. Rev. David Evans of Grace Church San Francisco held the opening services in Forester's Hall. In 1906, a plot of land was purchased on which to build a church. Arthur Darwall, a lay reader, conducted services in Forester's Hall until the Grace Episcopal Church building was completed in November 1906. The opening services were held by Archdeacon Emery of Grace Cathedral, San Francisco. The building now houses the San Lorenzo Valley Museum.

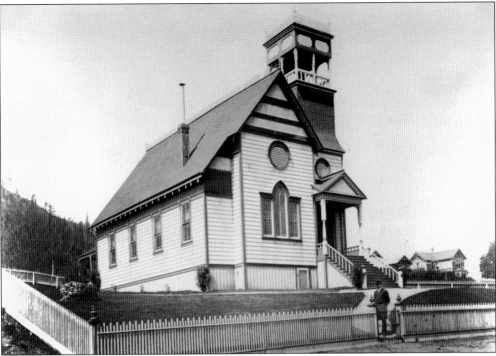

The Boulder Creek Presbyterian congregation organized in 1890, and the first church building was dedicated in 1891. The building burned down in 1893 and was rebuilt. Pictured above is the second building, and below is the Sunday school on the grounds to the rear of the church. When the second building was torched by anti-prohibitionists in 1909, a reward was posted for information on who set it ablaze. Since the congregation had declined, the church was not replaced. Its bell, however, was saved and is mounted outside the Methodist Church in Boulder Creek.

Pictured here is the current Boulder Creek Methodist Church building, which was constructed in 1908 after the previous building was torched by anti-prohibitionists during a dispute about the banning of liquor sales within the town boundaries. The previous church building had been constructed in 1885 in what was then called the town of Lorenzo.

In 1897, Henry L. Middleton donated two lots adjacent for the building of a Catholic church, and work on the construction of the church began in 1899. St. Michael's Church was dedicated in October 1900, and in 1904 Middleton donated an altar. The church was razed in the 1950s, and a much larger facility was built to support the growing congregation.

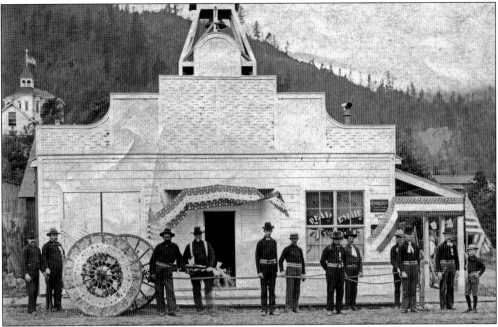

This photograph was taken on the Fourth of July 1900 in front of the Boulder Creek Firehouse on the corner of Central Avenue and Forest Street. Volunteer firefighters Isaiah Hartman (second from the left), Jake Hartman, Kores Hayes, Henry Waters, Charlie Perkins, Fred Moody, and Billy Dool stand with the decorated Boulder Creek hose cart.

This is the Felton Woodpeckers baseball team around 1900. They are, from left to right, (first row) Harry Steen, Wally Drew, and Ed Willis; (second row) Dick Rountree, Hyman Steen, Tom Addington, ? Edwards and Frank Enos; (third row) George Ley, Jack Russell, Calatzi, Ed Daubenis, and Duffy.

Pictured here are the players of the Boulder Creek Baseball Club, the Sawfliers, in the early 1900s. Dan Trout, the town's postmaster, was the manager of the team. There was a great rivalry between the club and the Felton Woodpeckers. The players are, from left to right, (first row) Foster McAbee, Jim Maddock, Ernest Bloom, Dick Smith, and Will Peery; (second row) Charley Boyce, Arthur Bowden, Dan Trout, Johnny Hayes, Charley Wiley, and Lavelle Trout.

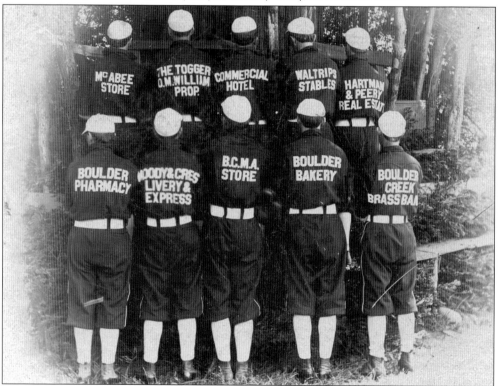

Ten

THE WAY IT WAS

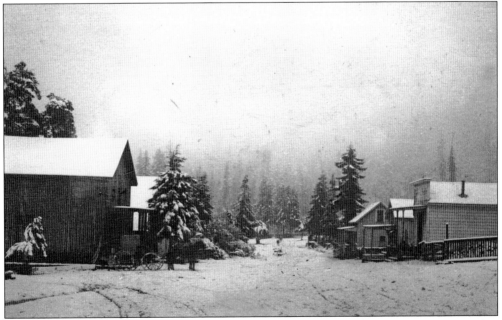

This 1893 snow covered street in Lorenzo is now Highway 9. While unusual to have such a covering of snow, it is not unheard of. When the flume was in operation from 1875 to 1888, just a dusting of snow could be costly as snow laden branches easily break and damage from falling limbs ensued. In 1884, it was reported that there were 10 inches of snow in Ben Lomond.

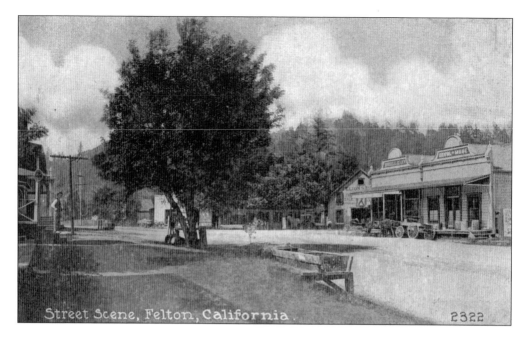

Street Scene, Felton, California. 2322

The general merchandise store in Felton (at right, above) was owned by William Russell, the superintendent of the Felton limekilns, and George Ley Sr. Russell was a stockholder in the H.T. Holmes Lime Company. One of the four kilns at Felton was stated to be "of a new kind, something never seen before in this section, an invention of Mr. Wm. Russell." In 1885, Russell was shot by Louis Anderson after an argument. After a manhunt, Anderson was shot and killed a few days later. Behind the store in the center of the picture below, a Southern Pacific locomotive can be seen as it approaches Felton.

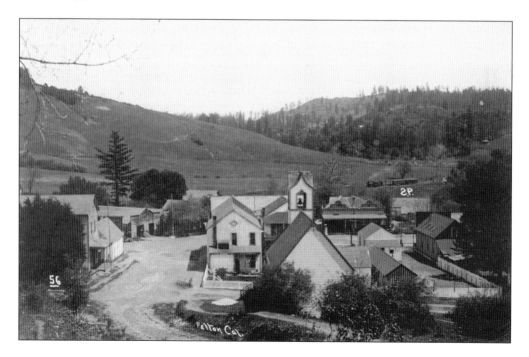

Felton Cal.

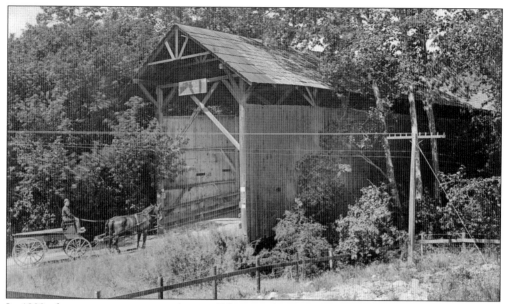

In 1892, there was a serious accident in Felton as the unsafe bridge between the town and the depot was being replaced. The contract was awarded to Cotton Bros. of San Francisco. A structure, called false work, supported by guy ropes was erected to allow for the old bridge to be dismantled. Unfortunately, the ropes gave way and the six men working on the bridge were plunged into the river below. All were injured, and one, the foreman, suffered paralysis. (Courtesy of the Ronnie Trubek Collection.)

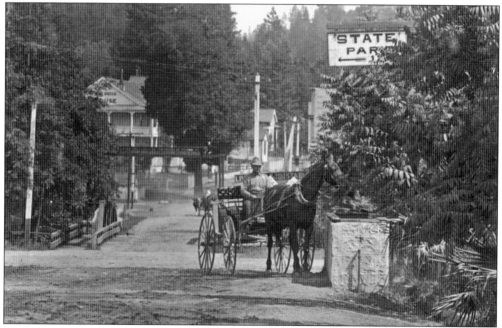

This is the bridge on Highway 9 over Boulder Creek looking north. The sign above the bridge reads, "Five dollar fine for riding or driving over the bridge faster than a walk." In 1888, a tollgate was erected on Bear Creek Road. During a dispute, the tollgate was torn down and the tollgate sign was installed over the bridge.

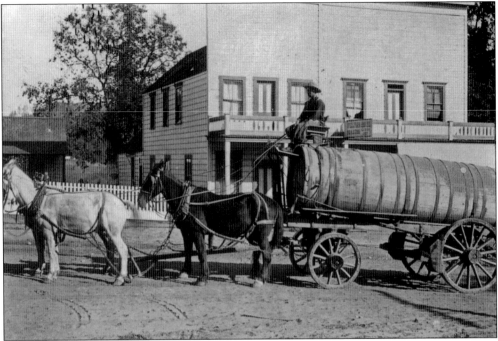

This water truck stands in front of the Felton Hotel, known also as the Cremer Hotel. Such trucks were used during the summer months to sprinkle the unpaved roads to keep the dust and dirt at bay. The trucks would be filled with water from water towers. In 1907, two new tanks were installed to hold water for street sprinkling.

Oxen were also used instead of horses for personal transportation. Tragically this ox, pictured here outside the Basham Cottage in Boulder Creek, killed its owner and driver shortly after this photograph was taken.

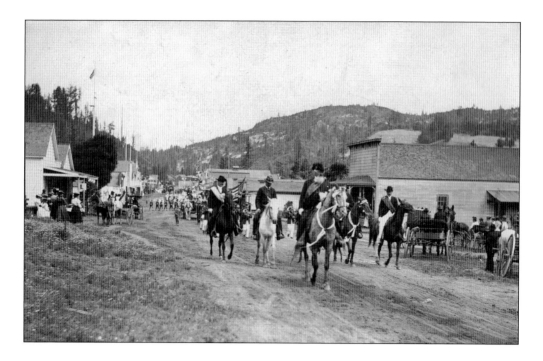

A time-honored tradition in Boulder Creek is the Fourth of July parade. Above, around 1900, Samuel H. Rambo leads the parade heading south along an unpaved Central Avenue. Pictured below is John James Moody of Moody and Cress Livery Stables driving the float behind Samuel Rambo. The float featured the Goddess of Liberty portrayed by Minnie Stagg, Rambo's niece. The two lead horses are Bob and Bess. Behind them are floats and community organizations.

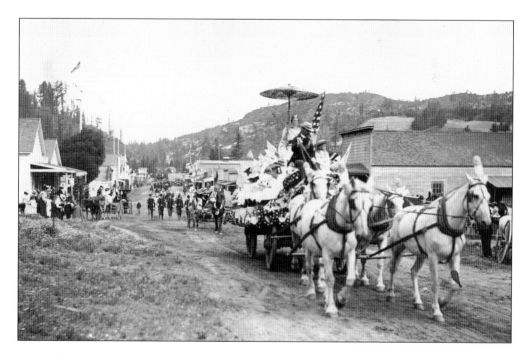

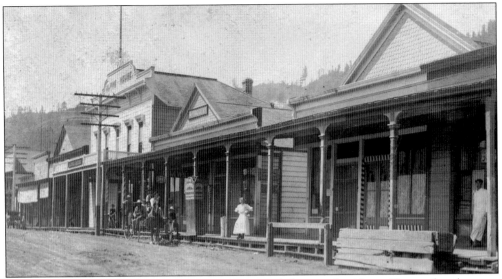

In 1902, Boulder Creek voted to incorporate. Pictured above is the Alpine House after the town incorporated. After incorporation, property owners shared the cost of improvements to the town depending on their frontage. Streets and sidewalks were improved; sewer lines were installed, and in 1920 Central Avenue was paved. Pictured below is such work being carried out on Central Avenue. By 1915, the townsfolk were divided. Those in favor of remaining incorporated cited improvements, such as cemented sidewalks, an illuminated downtown, a park, and a library. Those who were opposed blamed the vacant lots and falling school attendance on the increased taxes. Also a factor was the aggressive and successful campaign by the temperance movement to close the saloons in town. Without their tax income, the town would find it difficult to pay its expenses. Facing financial difficulties in 1915, the town voted to disincorporate.

Looking east down Mill Street, Ben Lomond Mercantile is on the left. The store was opened in April 1906, just one day before the earthquake by Benjamin Dickinson and Norwegian Rasmus T. Lyng. Its name was later changed to Dickinson's and was family owned until 1965. On the opposite side of the street was the Ben Lomond post office. It was built as a residence in 1890. William Nicholson was the postmaster from 1899 to 1934.

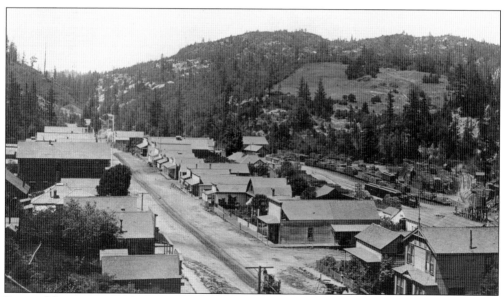

Pictured here is Central Avenue, Boulder Creek, looking northward, with the rail yard and depot located on what is now Railroad Avenue. The WCTU building can be seen in the lower right. The large building at center left is the IOOF building. The roads are not yet paved and the sidewalks are made of wood.

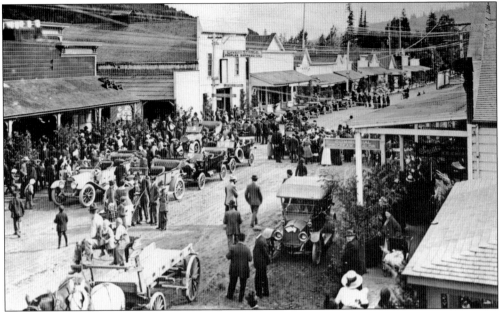

In October 1914, the governor of California, Hiram Johnson, visited the California Redwood Park at Big Basin. Boulder Creek prepared a reception for the governor. All the park commissioners were present, as were the members of the California legislature from San Mateo, San Benito, Santa Clara, and Santa Cruz Counties. The reception was in part "a mark of appreciation for his signing the $70,000 road bill, which opens the park on the San Francisco side, and gives an exit through Boulder Creek." Pictured below in Brookdale, Governor Johnson holds a redwood burl key presented to him by Joseph Aram on behalf of the town. The burl key, about 12 inches long, was donated by Henry L. Middleton.

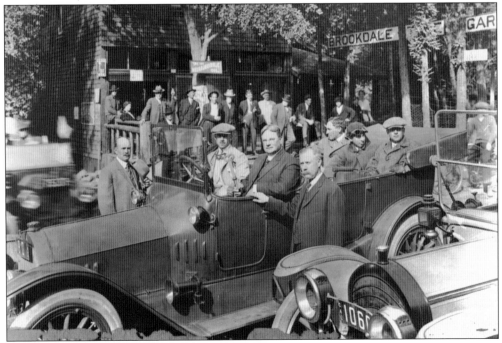

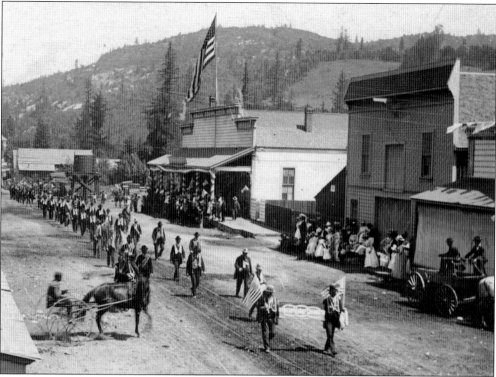

Pictured parading above are the Independent Order of Odd Fellows in the Fourth of July pageant. Unlike today, the parade began at the north end of town and moved south. The Middleton store is pictured in both photographs. The lower image depicts the huge volunteer fire crew in their uniforms standing with the hose cart in front of the store. The two youngsters and drummer with them are also in uniform.

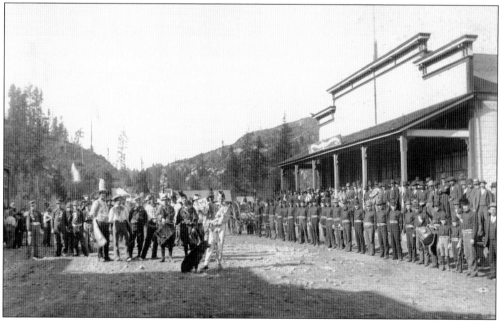

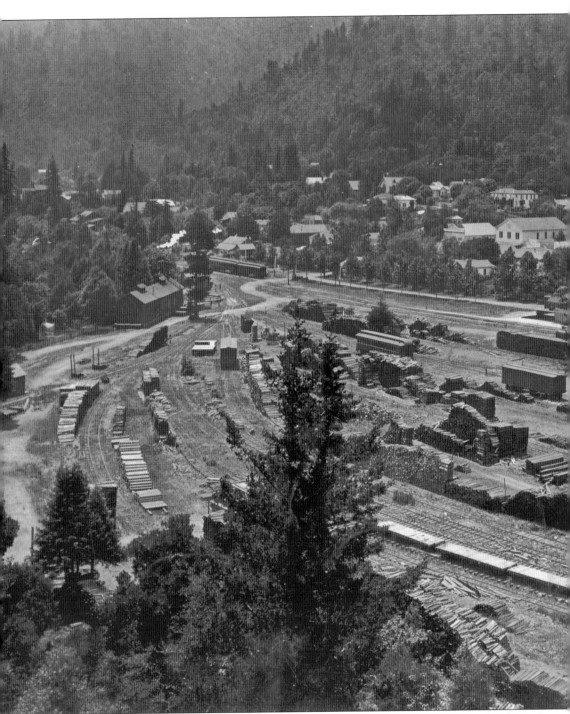

Looking south at the Boulder Creek railroad yard, piles of lumber are stacked ready to be shipped. The photograph was taken around 1906, about the time of the earthquake. Although Boulder Creek and Ben Lomond suffered similar, but little damage in the earthquake, the news reports from Ben Lomond and Boulder Creek paint quite different pictures. While Ben Lomond reported, "there is hardly anything to say regarding our own little town," Boulder Creek reported in detail

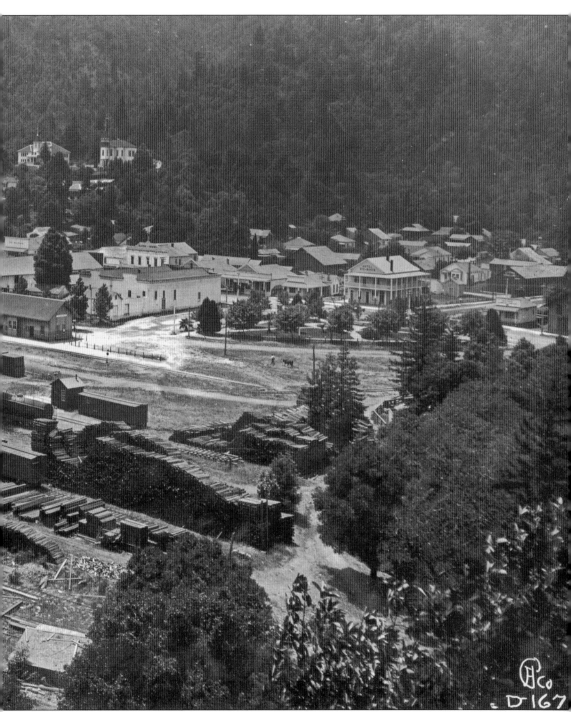

on the damage done, mostly fallen chimneys and flues. There was, however, a "terrific cataclysm" on Deer Creek, where a huge landslide plummeted down the mountain killing two men, James Dollar of Ben Lomond and Francis M. Franklin of Boulder Creek, at the Hoffman Shingle mill on the Hartman tract. "The mill cabins were crushed like eggshells and the mill itself disappeared under the moving wall."

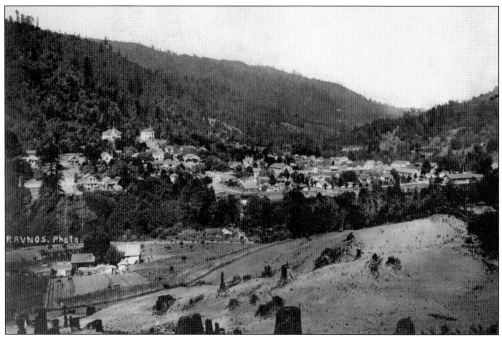

This view looks west down the Boulder Creek Valley towards Big Basin State Park. The property in the foreground is the Conrad J. Schroeder ranch. The timber trees have been harvested and Schroeder used dynamite to blast the tree stumps so he could plant crops. In 1905, the Schroeder Bridge over the San Lorenzo River was damaged by such a blast.

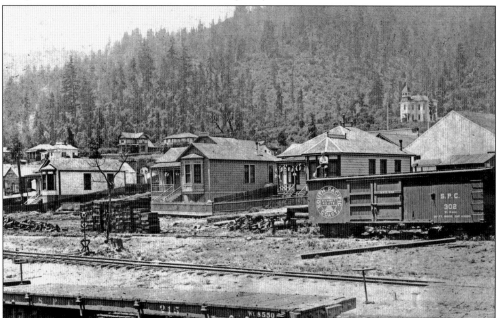

Today, these properties face Railroad Avenue in Boulder Creek. The grammar school stands alone on the hill in the distance, indicating that this photograph was taken prior to 1906. Notice the man sitting on a chair atop the South Pacific Coast freight car; the building behind him now houses the Little People's Preschool.

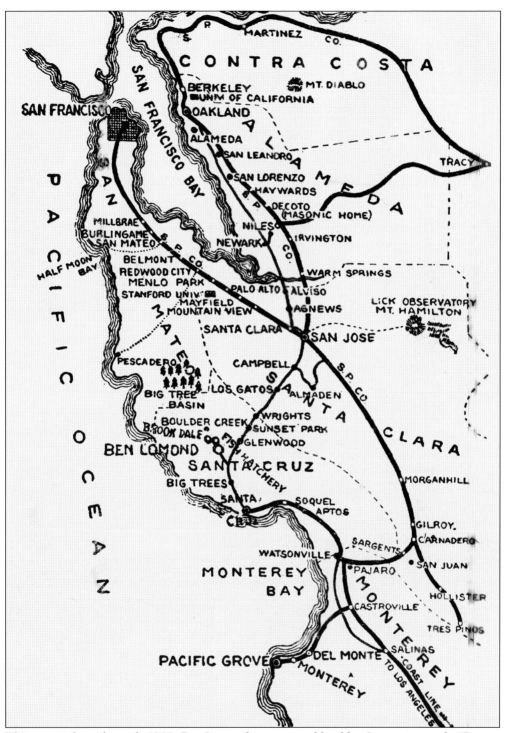

This map is from the early 1900s Ben Lomond promotional booklet. Its caption reads, "Do not fail to visit Ben Lomond when in Santa Cruz, only 10 miles. Thirty minutes ride; 60 cents round trip; 4 trains daily."

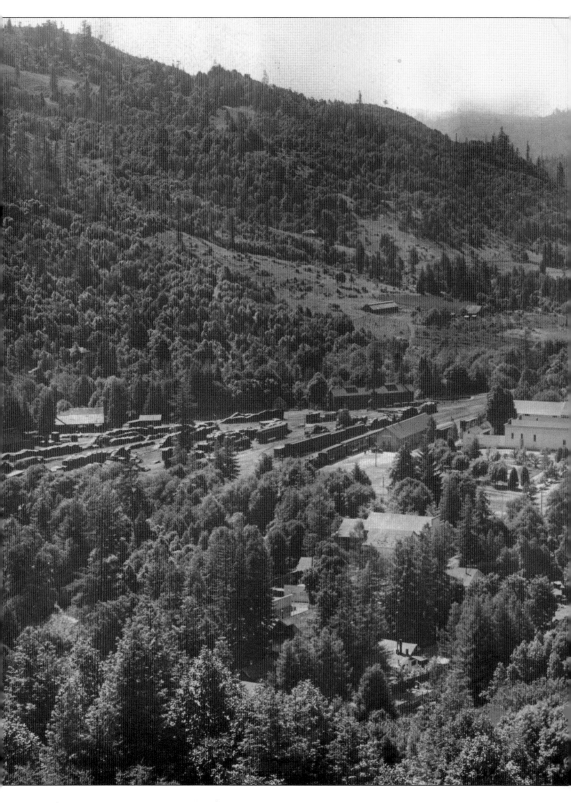

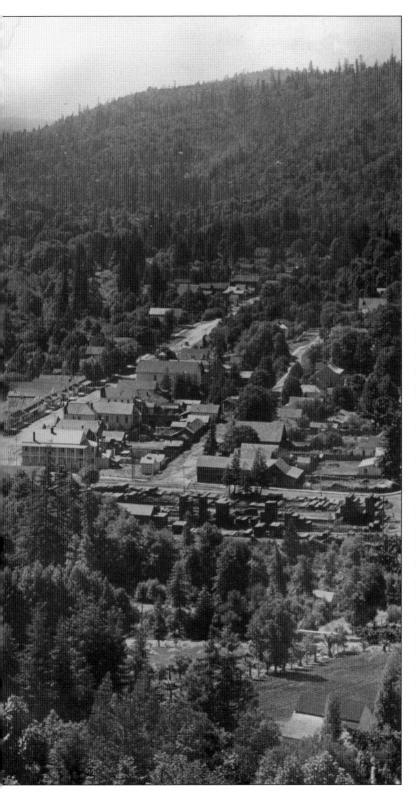

Looking south down the beautiful San Lorenzo valley towards Felton and Santa Cruz, it is not difficult to imagine this scene 200 years ago. The mountains and trees dominate the view, and it is easy to visualize the valley without the structures. The river was named San Lorenzo on October 17, 1769, by Majorcan missionary Father Juan Crespí for Saint Lawrence. Father Crespí was on an expedition from San Diego led by Gov. Gaspar de Portolà to find the Bay of Monterey. He kept a journal and in it detailed his explorations. The expedition had missed Monterey, as it was shrouded in fog.

Index of Names

About the San Lorenzo Valley Museum

The San Lorenzo Valley Museum is located in the town of Boulder Creek, about 15 miles from Santa Cruz along the San Lorenzo Canyon. It was founded by the Boulder Creek Historical Society in 1976, and the first museum resided in a second-floor office just outside of downtown Boulder Creek.

Through a generous bequest, the historical society was able to purchase the historic 1906 Grace Episcopal Church building residing in what was originally the town of Lorenzo, and in December 1999 the San Lorenzo Valley Museum was officially opened to the public. In 2006, the museum building was recognized for its local historic significance by being placed on the National Register of Historic Places.

With a mission of preserving and sharing the history of the San Lorenzo Valley, the museum's programs include changing and traveling exhibits, educational outreach that includes docent-led museum field trips for local schools, colleges, and other organizations, historic walking tours, classroom visits by docents, and an oral history program, which serves to document the memories of long time residents. The museum also holds community events throughout the year that include historical talks, a community barbeque, and children's craft events.

DISCOVER THOUSANDS OF LOCAL HISTORY BOOKS
FEATURING MILLIONS OF VINTAGE IMAGES

Arcadia Publishing, the leading local history publisher in the United States, is committed to making history accessible and meaningful through publishing books that celebrate and preserve the heritage of America's people and places.

Find more books like this at
www.arcadiapublishing.com

Search for your hometown history, your old stomping grounds, and even your favorite sports team.